MARTIN MULL

Paintings, Drawings, and Words

MARTIN MULL
Paintings, Drawings, and Words

by Martin Mull

with a Foreword by Bruce Guenther
Chief Curator, Newport Harbor Art Museum

JOURNEY EDITIONS
Boston • Tokyo

First published in 1995 by
JOURNEY EDITIONS
an imprint of Charles E. Tuttle, Co., Inc.
153 Milk Street, Fifth Floor
Boston, Massachusetts 02109

Library of Congress Cataloging-in-Publication Data

Mull, Martin.
 Martin Mull: paintings, drawings, and words/ by Martin Mull:
with a foreword by Bruce Guenther.— 1st ed.
 p. cm
 ISBN 1-885203-19-5
 1. Mull, Martin— Themes, motives. 2. Words in art. I. Title.
 II. Title: Paintings, drawings, and words.
 N6537.M84A4 1995
 759.13—dc20
 94-46224
 CIP

Text and jacket design by Sherry Fatla

First Edition
1 3 5 7 9 10 8 6 4 2

Printed in Hong Kong

CONTENTS

for Maggie

Joking that he might well have been the blonde, blue-eyed poster boy for the Eisenhower era, Martin Mull in conversation often ruefully evokes the 1950s dream state of white, middle-class America. He thus illuminates a potent source of imagery for his paintings and their disconcerting domestic dramas. Mull, who was born and raised in the Midwest, understands the contradictions of that last great period of prosperity and cultural consensus, and in the Dick and Jane version of America that was his childhood. The amber-encased vision of small-town America, with its sense of well-being that empowers the World War II baby-boom generation, also disquiets that generation with an overriding sense of longing for a less contentious and simpler time.

Mull is particularly aware of the limitations of the worldview imposed by the 1950s and abetted by the emergence of television, that ultimate dream machine by which everything was made new. Television, with its assumptions about the nuclear family and stereotypical gender roles during that "last happy time," as John Updike characterized it, focused the promise of postwar America. That promise, of course, was soon undone—first through the questioning of society by the youth culture of the late 1960s, and then by each successive wave of newly empowered subgroup to emerge from our national fabric. No longer the nation founded on the reassuring homilies seen in "Ozzie and Harriet" or "Leave It To Beaver," America has become an unfamiliar and disturbing place. Mull's paintings function against that backdrop of flickering cultural memory, and within the collective unrest and individual disquietude of the present. His canvases invite us into worlds known and unknown, public and private, where everything becomes strangely familiar, but dislocated and uncertain.

At various times a musician, a comedian, and an actor, Martin Mull has always been an artist, and it is ultimately as a painter that he will be remembered. Mull has evolved from his early roots in the pop art and photorealism of the late 1960s to the pentimenti-marked surfaces and figuration of his current paintings. This volume documenting and celebrating his work attests to the need to make art every day. His drawings and watercolors provide a means for the spontaneous development of the objects, figures, gestures, and incidents that form the lexicon of Mull's oil paintings of the past decade. The cross-fertilization of 1950s popular culture with a cinematic freeze-frame penchant for the telling gesture gives Mull's work immediacy and a uniquely American voice.

The process of painting builds a sinewy layering of transparent and translucent imagery that alternately reveals and obscures the mise-en-scène of Mull's ironic tales. A Mull painting is a mysterious surface filled with an ethereal silence. At once bright and clear,

then poignantly shadowed, that surface defines a complex space of seamless transformation. Mull's canvases create strange inversions wherein abstract objects refer to real ones, and the familiar disappears into abstraction. The formed and the unformed mingle, pocket universes deployed by a mind filled with a revery of loss. Mull's canvases, like whispered voices telling almost-intelligible stories, invite the discovery of human profiles, domestic props, the sexually allusive, and the neutral form. Mull reveals the mythos of innocence through ever-shifting veils of colored light. Defining the specter of desire in a feathery profile, his canvases teeter in momentary equilibrium between childhood dreams and adult dilemmas.

The stroke of the brush, physical as well as ephemeral, takes the artist to places at once familiar but unknown. Drawing back the scrim of domesticity, Martin Mull suggests much about the inner life in ambiguous, almost indecipherable moments that are so transitory they seem to disappear just as they start to resonate with some emotional note. Spiraling through a domestic universe, the works enfold all within their reach in the not-so-delicate interplay of human attractions. Sensual and ironic, they seem to define what it costs to live within a particular skin, within a particular shadow of the present past. Mull's imagery, like whispered voices in our collective mind, exists, paradoxically primal, outside cognitive recognition. Without sentimentality or nostalgia, Mull reveals and dissects the lack of profound contact with other human beings as the malaise of our present and the darkness of our future.

Bruce Guenther
Chief Curator
Newport Harbor Art Museum

North Ridgeville, Ohio, during the late forties and fifties, was hardly the rival of even nearby Cleveland as a breeding ground for artistic expression. Nor was it the quaint, church-steepled paragon of Norman Rockwell's America—though, on those extremely rare occasions when art was even mentioned, it was invariably Rockwell's work alone that passed muster with the hard-working farmers' sensibilities. It was just a township, haphazardly populated, green turning brown in the summer, white turning gray in the winter.

This is not to say it was a hell-hole. On the contrary, it was safe as milk. Eyes-on contact with anything even vaguely resembling the visual arts was limited to comic-books, match-book covers, cereal boxes, calendars and magazines, but it did offer the visual stimulation of rusted tractors, claret-red barns, iridescent pheasants on the wing and the occasional aurora borealis. But, most importantly for a young boy interested in (of all things) art, it was the dearth of funds, the absence of television and the lack-luster, agrarian imagination that offered a distraction-free environment in which the magical world of drawing could open its seductive doors.

Years later, an art school professor of mine would suggest that a painter receives his inspiration from equal parts "looking at life and looking at art." Though I am sure that the professor intended for us to see the two endeavors as interdependent halves of some magnificent whole, I, as a pre-teen during those crew-cut, Eisenhower years, saw them as diametrically and mortally opposed. Perceiving my inherited and utterly quotidian surroundings to be an insidious form of quicksand, I saw Art as a means of survival and, ultimately, escape.

The decision to veer from the beaten path was not, as it may sound, the product of a tortured, romantic or even terribly colorful childhood. Those pictures made at the time were hardly the work of a "visual poet"—I can recall hours and hours laboring over a painting of Hermione Gingold (copied from a magazine, oil on shirt-cardboard) trying to "get the eyes to follow you around the room." However, what was developing in the face of all this seemingly fruitless effort was an earnestness and commitment. "Vunderkinder" I wasn't, but so was I undaunted. By the time I was ten years old I knew in my bones that I wanted to be an artist.

With the exception of inexplicable forays into the worlds of pole-vaulting and place-kicking, my sights were locked on art school throughout my secondary education and, in the fall of 1961, I entered the Rhode Island School of Design.

To say that art school changed my life would be a gross understatement: it created it.

By the ripe, old age of nineteen, I had discovered that painting was not a turn-it-on, turn-it-off, nine-to-five profession. It was, in fact, a way of life. A way of life with the richest of histories, endless amounts of information and inspiration available through libraries and museums and seemingly endless possibilities. Where better to be in the free-for-all sixties than the cloistered sanctuary of art school, surrounded by like-minded friends, thirty-five-dollar-a-month apartments, walking-distance art stores, bars, Chinese restaurants, and the consciousness-altering omnipresence of rock and roll?

No matter that my buying a guitar and butchering folk songs as I sat, night after night, in my studio staring at a recalcitrant, non-objective tour-de-force was as commonplace as headbands. No matter that the cannabis-inspired Pen-tel drawings were moronic come morning; no matter that the wine-softened interpretation of Kierkegaard was offered by an eighteen-year-old named Debbi while a roomful of would-be de Koonings focused on her see-through Indian blouse; this was our Paris of the 1920s and it would change our lives forever.

The grand total of my formal art education: Three years as an undergraduate in Providence; a truncated senior year of free study in Rome (courtesy of the school's European Honors Program); and two more years in Providence securing a master's in Fine Arts—a teaching fellow during the latter.

There was no such thing as a doctorate in painting. Had there been, I would have gladly stayed in academia. As it was, no defensible excuse to stay presented itself, and so, I was forced to face the equally grim, post-graduate prospects of a Viet Nam-fueled military draft or pedaling my basically worthless degrees around in search of gainful employment. As luck would have it, the Army examiners concluded that my Neo-Bohemian, aesthetically driven lifestyle was symptomatic of mental illness (Irreparable Neural Damage was the actual term I saw scrawled across the top of my chart) and I was not only excused but shown out the back way so as not to get too close to the other conscriptees. One down; gainful employment to go.

It was unrealistic, if not downright laughable, to think of supporting myself with my artwork. Likewise, the thought of expanding one of the part-time summer jobs—moving-van loader, tennis court sweeper, janitor or dishwasher—was pushing the limits of even my hippie/existential pride. What was needed was the classic "artist's day job" and to this end I turned to my by now passable abilities as a guitar player.

Rock and roll performances were becoming virtually indistinguishable from the avant-garde "happenings" in the fine art world, and this made the decision to put my creative energies into music and performing seem anything but "selling out."

"Soup" was the name of the band—so named because of the mix of theatrical, musical, literary and comedic ingredients it attempted to amalgamate. Odd enough (and loud enough) to attract attention, we soon had a contract to record for Vanguard Records.

As for the diligent and dedicated painter? In the short span of eighteen months, my

entire involvement with the visual arts had shrunk to the size of the album cover. And then the bottom dropped out.

In what felt like one fell swoop, Vanguard decided the album was unreleasable, the band broke up, my long-time girlfriend bought a one-way on the Greyhound, and the pipes froze solid in my unheated, badly arreared and about-to-be-condemned-anyway apartment.

Ah, the B-movie drama!

Thanks to the resilience of youth and the inordinate kindness of friends, I soon found work in a recording studio as well as a serviceable basement apartment. And, thanks to re-discovering a Disney picture-book from my youth that contained a mesmerizingly enigmatic drawing of a flying chair, I rekindled my interest in painting.

I was fascinated to the point of obsession by that little chair. Perhaps because it represented a life raft at a time when one was sorely needed or perhaps because it harkened back to simpler, less-informed times (I was currently of a mind that I had "learned too much" in art school). Whatever the reason, for the next eight years I would develop, re-invent, interpret and anthropormorphize that chair into scores of drawings and paintings executed with vinyl paint on clear acetate, painting "backward," as it were, the way animation cels are prepared.

During this period of fairly prolific output I joined forces with Boston-based artists Todd McKie and Fred Brink and we formed "Smart Ducky"—a light-heartedly anarchistic,

Neo-Dada art group best known, at least locally, for an exceptionally and intentionally inept, seventeen-minute film entitled *Mondo Linoleum*, and the "Flush With The Walls" or "I'll Be Art In A Minute" exhibit at the Museum Of Fine Arts, Boston.

The latter was an extremely unsanctioned guerrilla-style exhibit of small works that were smuggled into the hallowed halls and hastily displayed in the museum's men's room.

By the early 1970s my life was, if not normal, at least governed by a semblance of responsibilities and regularity. I had married, moved to New York City and released a couple of moderately successful recordings

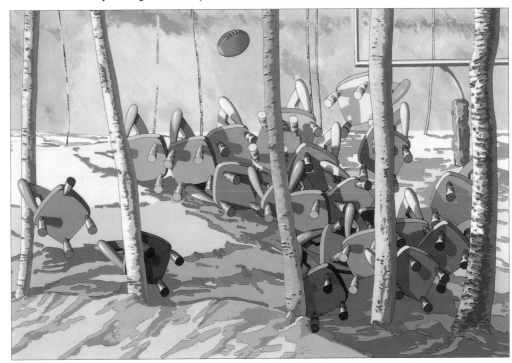

FIELD GOAL
Cel Vinyl on Acetate 8½ inches x 12 inches 1981

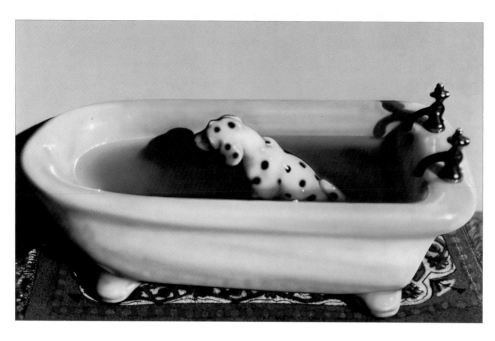

DOG IN TUB

Airbrushed Acrylic on Canvas 50 inches x 68 inches 1984

of my own music. As my "day job" grew in its scope to include not only recording but an increasing number of concert and night-club appearances, so, too, it became more demanding of both my time and creative energies. However, fully convinced that it not only could, but would, screech to a halt at any given moment—putting me uncere-moniously behind the wheel of a Checker like any other self-respecting painter—I did my best to keep it in proper perspective, continuing to paint, wherever and whenev-er possible, through eight record albums, innumerable performances in what felt like every cafe-torium in every backwater State Teacher's College in the union, and a divorce.

By the mid-seventies, my wage-earn-ing activities had grown to include fairly regular forays into television and a movie or two a year. With this redefinition of my so-called career came the necessity of relocating to California.

Life in Hollywood was decidedly different. So drawn was everyone and everything into the vortex of show business that it was virtually impossible to do or say anything with-out someone suggesting that it might make "good panel." If my friends and associates con-sidered my interest in art to be something akin to bottle-cap collecting it was because I gave them good reason—I had no studio, and spent most of my free time either jamming with musician wanna-be's or draining single-malt scotch bottles at industry-approved watering holes. Though I might pull off the infrequent drawing, watercolor or cocktail-nap-kin portrait, it was hardly the by-product of a discipline. I must confess that the last half of the seventies were spent with my head in the insubstantial clouds of celebrity.

One month into the eighties I was diagnosed as having terminal melanoma cancer.

Though unswervingly convinced that this was some sort of cosmic clerical error (and to this day of a mind that that conviction was nine-tenths the cure) the news was, nonethe-less, sobering. Foremost among my reactions was an undeniable urge to paint; to paint, ironically, as if my life depended on it.

I immediately exhumed my cel-painting paraphernalia and, in a few short months, had a body of work and the first of several gallery showings with the Molly Barnes Gallery in Los Angeles.

The other knee-jerk reaction to my brush with mortality was to uproot myself from

Malibu, and all that it entailed, in favor of bachelor digs—with a serviceable studio—in the Hollywood Hills. It was henceforth that painting became a daily and fundamental part of my life.

The images and elements of those paintings done between 1980 and 1983 became gradually more rendered in their depiction and, even though the mental and technical challenge of achieving this somewhat trompe L'oeil appearance was intriguing (i.e., painting backward), it was ultimately unsatisfying. I decided to plunge headlong into photorealism, and a four-year battle with the airbrush was begun.

Why photorealism? Hindsight tells me that I opted for this eye-ball-burning genre for a number of reasons: Firstly, the images I depicted owed more than a passing nod to those infamous "dogs playing poker" and "kittycat's moving day" postcards and I was under the delusion that I could integrate my public persona—essentially that of a humorist—into my work (thereby eliminating at least part of the inherent schizophrenia that attends the wearing of two conspicuously different hats). Secondly, despite the astounding efforts of Kandinsky, Pollock, Rothko, et al, the average unenlightened (and often enlightened) view-

er is still impressed by the anal-retentive limning of recognizable subject matter. My re-commitment to painting being relatively recent, I needed the positive reinforcement of the gallery and museum shows (not to mention the sales) that these works engendered.

Thirdly, photoreal airbrush painting was, for me at least, not so much a means of expression as a demanding and exacting skill, the mastery of which further bolstered my denial that alcohol was rapidly becoming the predominate chemical in the studio.

By the fall of 1987, I had a career that had settled into the relative security that involvement with show business can offer, the beginnings of serious acceptance in the fine arts community, a remarkable and supportive wife, a precocious two-year-old daughter, and the excruciating realization that all of it hung in the balance of one more cocktail.

At the age of forty-four it was time to grow up. Needless to say, the rediscovery of

LUCKY
Airbrushed Acrylic on Canvas 36 inches x 36 inches 1985

sobriety after twenty-some-odd years alters every aspect of one's life, but nowhere were the effects more evident than in my painting. After a lifetime of slavish servitude to the non-artistic needs of social insecurity, immediate gratification, and self-definition, painting finally became the subject and I the verb.

I abandoned photorealism and made the decision to start over from scratch.

To say that I went back to art school would not be inaccurate, however, this time the school was my studio and I the student body of one. Beginning with basic drawing and study of the masters (notably Matisse), I slowly worked toward smallish paintings. And, as my confidence grew, I began to allow my inspiration to come from the deeper, and sometimes darker, recesses of my subconscious.

It is the results of these explorations—those moments when doors opened like a prison break as well as those when the locks had to be picked—that constitute the works chosen for this book.

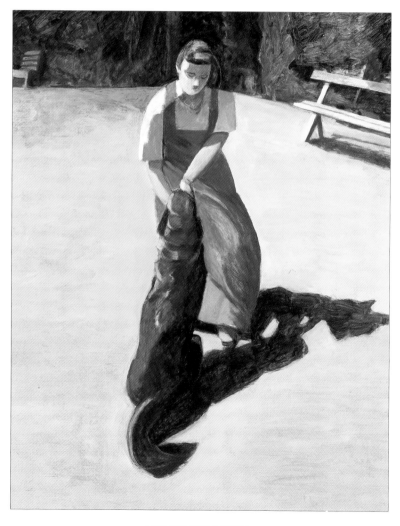

WENDY AND LUCKY
Oil on Canvas 23 inches x 19 inches 1989

once heard a story about a painting instructor who told his class that "talking about art is like dancing about architecture." Immediately upon hearing this, one of his students leapt to his feet, did an impromptu tap routine, and proudly proclaimed his fancy footwork to be the Flatiron Building.

And so, with little more than this snippet from academia to guide me, I will now undertake the fool's errand of attempting to describe the methods and madnesses that constitute the process by which I make pictures. If contradictions, redundancies and esoterica abound and the works reproduced herein appear to be antithetical to the philosophies expressed, then I can only offer that mine is a process in flux. Many of the ideas and attitudes submitted here were either unthought of or invalid a mere decade ago, so I can only assume that the current crop will one day prove to have been provisional. I don't say this as a disclaimer, only to stress that the following is a description of a point in a storm.

In other words: The Chrysler Building.

Though I consider myself to be disciplined (perhaps to the point of being driven) and spend the greater part of every day in the studio, I have no set agenda. No step-by-step, craftsmanlike schedule that oversees a painting from beginning to end. Cleaning brushes, spackling studio walls, painting like a dervish or staring like a zombie—the lines of demarcation between artist, artisan, and custodian are blurred and, hence, any sense of routine.

However, in an attempt to give the following at least a semblance of order, I have divided the process into aspects or phases and sequenced them to follow a hypothetical painting from conception to completion.

DRAWING

For me, drawing is the extension of sight—as logical and automatic a response as speaking is to thought. It is through drawing that an idea can shed its literal meaning and take on the heightened reality of visual experience.

I draw to touch base; to de-brief myself from all but visual and sensual reality, and, like a businessman checking his answering service, to see if the muses are biting. Far too often, they are not. Though I try to approach each drawing without preconception or intent—preferring, instead, to let the first mark on the page be the last purely willful act and the other marks to be engendered by those that precede them—most of my drawings evolve into themes and variations of other works with which I am currently involved.

However, on occasion, I will find myself in uncharted waters. Perhaps the muses have deigned me worthy of a house call or perhaps the intensity of my concentration has

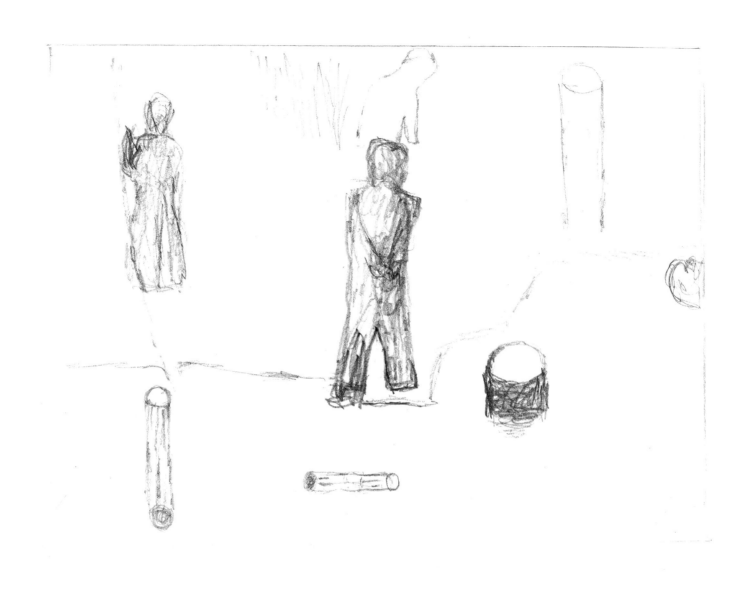

STUDY FOR CROSSING
Pencil on Paper 5¼ inches x 7 inches 1994

obliterated all other realities save the one inside the picture plane. Whatever the reason, the feeling is one of actually stepping into the space and time of the drawing: no longer a draftsman, but an exhilarated explorer, I blunder and poke my way around this Oz in search of those emergent symbols and images that seem charged with "long-lost" emotion.

I say "long-lost" emotion because these images are not whole-cloth inventions or creations (else how would I recognize them?) but manifestations of life-experiences that eluded my consciousness the first time around or were fully and deeply experienced and then suppressed for a myriad of reasons.

The specific images that arise in these drawings hold a personal and powerful significance for me. They are landmarks on a psychic map and, as symbols, they become part of a glossary of visual elements that frequently recur in my work. I should point out that much of the potency of these symbols is owed to their context within the original drawing and that "transplanting" them to other works often obviates their significance. However, even in this diminished capacity, they still serve as trusted points of departure.

Even rarer than these drawings that offer piecemeal contributions to a "visual vocabulary" are those where the integrated whole is emotionally evocative: drawings where the extrinsic value of the individual elements is superseded by a sense of order, harmony and an all-pervasive "air." If the former can be considered a "dramatis personae," then the latter are the play itself.

That these pictures have attained a certain sense of inner peace and can sustain themselves as objects without constant personal and narrative reference would be impossible were it not for a solid, organic structure. The extent to which I understand (and feel I can re-create) this structure is the determining factor in the selection of one of these drawings as a point of departure for a major painting.

Finally, there are those moments—alas, precious few—where I feel I have drawn "as directed." This is to say, from start to finish filled with the sense that I am merely a conduit and powerless to do anything but set down the information that actually floods in from God-knows-where. Immediate, undeniable, and filled as they are with ecstasy and terror, it is moments like these that have made the making of pictures so addictive.

WATERCOLORS

Although I never intend for my watercolors to be ends in themselves, there are a few done in recent years that I consider to be among my best works. I wish I could take credit for them.

It is the most unforgiving of mediums. A pencil drawing can withstand countless erasures and additions—and often take on a distinctive, evolutionary quality in doing so. But a watercolor is virtually "uncorrectable," and quickly falls victim to overindulgence. For a person who embraces the trial and error method of exploration, the prospect of creating a sparkling, airy, light-infused watercolor would seem bleak.

Hence, there is a certain trepidation that I feel beginning a watercolor; a trepidation born of the knowledge that the first mark on the paper must survive the entire process. The obvious antidote would be, of course, precise preconception and grand facility. (Watercolors are notoriously the showdogs of the glib and unadventurous.) However, preconceived pictures hold no interest for me. Therefore, I am forced into acting not only on intuition, but on an intuition that is constantly altered and challenged by the vicissitudes of the paint and paper.

And such vicissitudes they are! The vehicle is water (you remember, folks, that amazing stuff that takes the shape of its container?) and it is literally alive. It is subject to gravity, agitation, temperature and shrinkage; colors can co-mingle, constrict or exhale into broad fields and, depending on the method of application, wend their own willful way across the paper—leading as well as responding to the painter.

In essence, I am as much a witness to these works as I am an active participant and, as such, I am able to maintain the aspirations and philosophies that prevail in my drawings. As with my drawings, images and symbols materialize, but now their interrelationships are greatly intensified by the presence of color. All of the requisite formal ingredients for a fully realized painting are present, consequently, to consider these small pictures to be "colored drawings" or "stepping stones" between drawings and serious paintings would be inaccurate.

I mention that my watercolors are generally small—often the size of a postcard or playing card. Though this is partially in the interest of manageability (often the "studio" is a hotel room or movie-set "honeywagon"), I attribute this fact in large part to be an outgrowth of my earliest, and to this day, most extensive, encounters with the world of visual art: art books.

The number of masterworks that I have seen in the flesh is a comparative handful next to the number I have pored over and scrutinized in the hundreds of books that have worn a hole in my lap. Reduced, flattened, and faded as they may be, these reproductions have served as my bible. They have become so much a gospel that, when I've had the good fortune to view the real McCoy, I have often found myself confused and jolted into the realization that I have never seen anything like it before.

Having learned so many of the formal considerations of picture-making from images no larger than a book allows, I feel comfortable, at least in drawing and watercoloring, working in the same format. Further, I suspect my hope is that the silent intimacy that books create will be echoed in the paintings.

OPAQUE PROJECTION

My use of opaque projection would seem to be in direct conflict with my professed pursuit of the unpredictable aspects of picture-making. This is not so.

A decade ago, when I was knee-deep in the quagmire of photorealism, the opaque projector proved invaluable as a means of transferring a drawing or photograph to canvas.

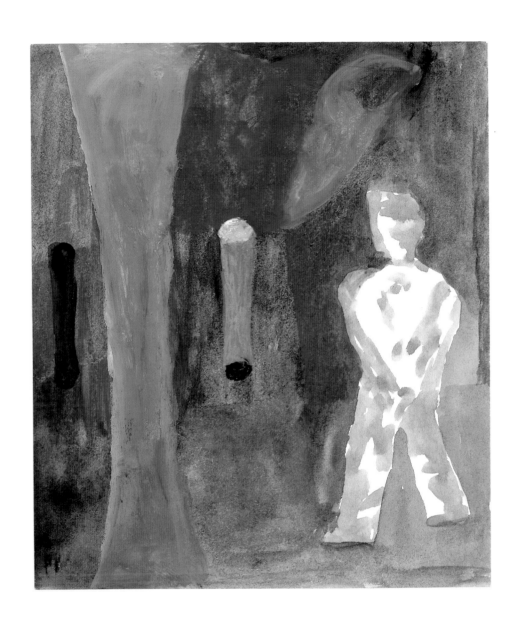

STUDY FOR CROSSING
Watercolor on Paper 5¾ inches x 5 inches 1994

Even though my goal at that time was the slavish, retentive outlining of every minuscule shape and color shift, I recall being struck by how dramatically different images, especially drawn images, would appear after such a drastic change in scale. Regardless of how representational the original might be, the projected image was instantly an abstraction. Lines became dots and smudges, seemingly uniform fields of color became scumbled and pock-marked, familiar images (now enlarged well past "life-size"), became alien, and, pictorially, spatial relationships inverted or flip-flopped all over the place. The sensation was not unlike looking at those examples of microphotography where the head of a pin appears as a lunar landscape.

Most importantly, the projected drawing was so violently altered from that which I assumed I knew it to be that I was no longer the author. I could become the audience. Coupled with the objectivity afforded by this new-found detachment was the rush of excitement that was always sponsored by the sight of an incandescently-glowing, now wall-sized image.

Though I no longer use the opaque projector as a tool for transferring drawings, I still find it an exciting piece of equipment. Sitting for an extended period of time in front of a monumental and illuminated image, the correlation with stained glass windows becomes unavoidable and, perhaps by association, evokes a feeling of spirituality.

On a much less metaphysical level, the mere fact that it is a "piece of equipment" is important to me. After days or even weeks of drawing and watercoloring—sedentary and introspective activities that they are—the idea of using "equipment" is refreshing and helps shift the studio back into the "workshop" mode.

Typically, several days will be devoted to studying and examining the current crop of watercolors and drawings by means of projection and, generally, one of these works will become a contender for a larger painting.

In order to "make the cut," as it were, the image has to not only retain its context in the larger format, but actually gain a significant evocative quality by finding its full dimension. By "full dimension" I am referring to the fact that I regard the smaller works, for virtually no other reason that their size, to be "windows" into a larger reality. The work on larger canvases, however, and with rare exception, I view as not "about" something, but the thing itself.

Determining the size of the canvas—a subject worth examining on its own—is done by adjusting the focal length of the projected image until a feeling of "rightness" occurs.

SIZE

There are several considerations that go into determining how large a given painting is going to be. Some are grounded in aesthetics and others in plain old common sense.

Common sense rule number one (and learned the hard way): Never build a canvas that won't fit through the studio door. Rule number two: Never build a stretcher that's larger than the material you wish to stretch. (Here, again, experience proved the best teacher.)

As for the aesthetic considerations: I believe that all sense of proportion is grounded in one's own corporeal awareness. Such standards as "wider than I can reach," "taller than I am," "about my size" and "something I can hold in my hand"—arbitrary as they may sound—are not only basic, but extremely valid considering that at least one definitive quality of a work of art is its ability to relate to the human condition.

Along with this physical "measuring up" between viewer and object there is an emotional "balancing" between the two. Whereas a monumental piece has the potential to fill the viewer with awe and, therefore, disarm him of preconceptions, an intimate, "window-ish" work may prove to be a Trojan horse—initially empowering the viewer, only to seduce and disarm him once the invitation to "enter" has been accepted.

For a figurative painter (which, for lack of a better definition, I suppose I am) there is also the fact that the human form can be depicted as life-sized, larger-than-life or smaller. Each of these options will sponsor a completely different emotional response.

Regardless of its size, the image that will ultimately reside on the canvas in question will probably have no relation whatsoever to the one envisioned there during this process.

And so all of this for naught? I don't think so. Immersing myself in these considerations is a way of personalizing the canvas as an object (and, after all is said and done, that thing hanging on the wall is an object) and giving it enough respect that it, too, has a say in the making of the painting.

THE CANVAS

I build, stretch, and size my own canvases and, for doing so, have earned the sobriquet "dinosaur" from at least one respected member of the local art community.

I'm sorry—it's that "personalizing" thing again.

I also enjoy it. An unhurried trip to the lumber yard to buy redwood, angles, screws, staples, and maybe a little wood-working "present" for myself is like a summer vacation before the school year of a new painting.

Likewise, the time spent in my garage cum woodshop is not time that I have, on occasion, thoughtlessly labeled as "mindless." If it were truly mindless, I would have lost a thumb by now. In actuality, building a canvas stretcher is as close as any part of the process gets to being an exact science.

More to the point, the uncomplicated pleasures of physical work are rejuvenating and, on a more philosophical level, the knowledge that the stretcher was built rather than simply purchased further bolsters my conception of the canvas as a unique object.

My canvas is not canvas—it's linen. This may seem to be only a matter of semantics, but I find the two as different as men and women. Linen is the latter.

I choose to work on a relatively heavy Belgian linen because of the subtly unmechanical nuance of the weave. Since so much of this weave is visible in the finished work, it becomes no less an integral part of the picture than a drawn grid might be.

I won't deny that part of the reason I have chosen linen over canvas is because of a

certain romantic appeal. It is earthy yet luxurious, stupidly expensive and generally conno-tative of "the old world"—and when you live in a town where making sitcoms is a priority, you have to grab your "culture" wherever you can find it.

The way in which I prepare and size the linen is also in keeping with "old world" tra-dition; however, there is a pragmatic motivation: Pre-sized, ready-to-use canvas, (or linen) has, by virtue of its mass-production, an anonymous quality. The mere fact that the canvas is "prepared" means that the surface has already been painted at least once, and probably by a machine at that. To my way of thinking, the application of any substance to the raw linen is, by definition, an act of painting (Francis Bacon, among others, painted directly on the un-sized linen) and should be considered as such.

PAINTING

I use hot rabbit-skin glue to tighten and seal the linen. Several layers of white lead are then applied as a ground.

The fact that I have included the application of the lead ground under this heading is intentional. First of all, it constitutes my initial exposure to the expanse and limitations of the pictorial space (the edges become the first four lines of the drawing and, given the amount of consideration that went into determining their dimensions, are far from arbitrary). Secondly, applying the lead pigment with a palette knife (the consistency of the lead is somewhere between a paste and a heavy cream) involves enough scraping, smoothing and inadvertent overlapping of layers that the surface takes on a definite infrastructure.

As the painting progresses, this inchoate "drawing" will impact the end result as greatly as any other factor in its creation, not simply because it will control the way in which the paint adheres to the surface, but because it is the first autonomous act of the painting.

Unless the "drawing" suggested by the inconsistencies of the lead ground is star-tlingly inspirational, I will begin the painting that I had originally envisioned, working from the drawing or watercolor that inspired it with only a minimum of alteration or compromise.

In doing so, the integrity and unity of the virgin canvas are destroyed. But this con-sciously destructive act achieves three main objectives: A commitment has been made; the respect for the canvas as an object, which can sponsor a ham-stringing "preciousness," has been (at least for the moment) removed; and a unique set of visual tensions, contra-dictions, and thought-provoking juxtapositions has been set up. In short, the breeding ground for a painting has been cultivated and the seeds sown.

If painting is, by definition, the applying of paint to canvas, then I would have to say that I spend very little time painting. The lion's share of my studio time is consumed by star-ing, watching, agonizing, and waiting for those impulses that will result in the application of paint to canvas.

What ensues, along with the waiting and watching, is weeks, perhaps months, of trial and error, a gestation period, wherein the "seed" composition is slowly altered, removed,

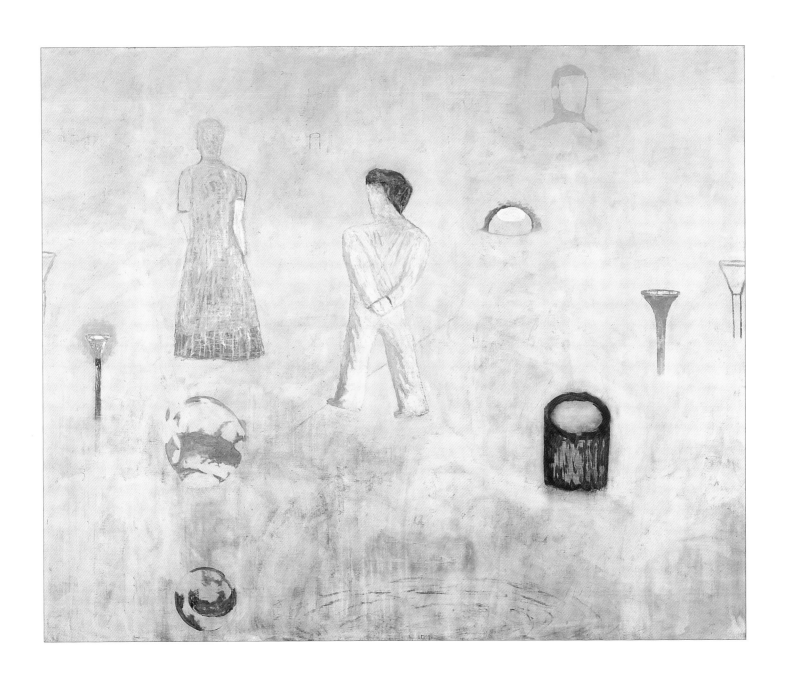

CROSSING
Oil on Linen 64 inches x 80 inches 1994

refigured, and adjusted until that alchemic moment when the painting responds with a faint but healthy heartbeat.

Call it a "secular epiphany," for lack of a better term. For divine intervention it isn't—at least not in the classic sense; no angels appear, no water turns to wine, and I am still blind as a bat without my glasses. Yet the emergence of an entity that is greater than the sum of its parts (and in spite of my pedestrian efforts) has a profundity that is for me no less epiphanic. The most vivid and telling of dreams pales by comparison.

It's been said that a great Zen master once described his method of carving an elephant from a block of ivory as "simply cutting away everything that doesn't look like an elephant." That would be an apt description of the task confronting me, except I'm not even sure that it's an elephant that I'm looking for. All I know is this: something extremely real, be it only a palpable tension, has made its presence known and, henceforth, the painting will be controlled by that force.

My role at this juncture, though it often feels like that of a desperate parent bringing toy after toy to a sullen child in hopes of coaxing a smile, is actually more that of an interpreter of sensation: in other words, understanding and identifying those sensations emanating from those parts of the painting that are "right" and synthesizing them into significant form.

Although this phase of the process is almost exclusively governed by intuition, it is also greatly assisted by the "visual history" that has been recorded on the canvas by virtue of the ongoing addition and elimination of elements.

By way of explanation, let me focus on the error side of trial and error for a moment. Every pictorial element that appears in the final state of a painting is preceded by dozens of images that have subsequently been physically removed. If the misappropriation is immediately seen (as is often the case) then the wet paint is easily removed. If, on the other hand, the particular image "establishes residency," only to lose its lease once the neighborhood changes, the removal can involve various solvents and physical abrasions. In this case, the error—like many errors made in life—never completely disappears.

Since the painting itself is no less responsible for these missteps than I am, I don't find these ghost-like traces to be negative distractions from the import of the work. On the contrary, I feel that the accumulation of these phantoms and vestiges establishes a legacy of sorts and a route toward the evolution of the final form.

While following this visual evolution often entails the addition of images that are anecdotal or narrative in nature, the final arbiter of whether any pictorial element lives or dies is exclusively formal consideration. Not only because, without strict adherence to the concept of the painting as an integrated whole, the painting could fall into the realm of illustration, but because focusing the entirety of my consciousness on the formal aspects of "pure" painting allows no other source for the subjective text than the subconscious or unconscious mind. Consequently, the possibility that the finished painting will evoke an emotional rather than a literal response is greatly enhanced.

Of those representational and symbolic elements that constitute the "subjects" of my paintings, there is little I can offer by way of explanation. I can state, categorically, that a certain mass of painted surface is red or green, glazed, impasto, architectonic or free-form because the ultimate harmony and expression of the painting required it to be so. I can only, however, speculate along with the viewer as to why certain atmospheres are decidedly interior, others reminiscent of landscape, and still others devoid of gravity and horizon.

It has been my experience that many people feel uneasy when they think they do not "understand" a painting. I imagine they would feel even more so if they knew that the painter is often equally in the dark. For those faint of heart who never leave home without a map, I can offer an exception: Those paintings of the last few years that were intentional explorations of Manet's *Le Déjeuner sur L'herbe* and Matisse's *The Piano Lesson* owe much of their imagery and structure to their sources. However, even in these essentially derivative works, the minor amendments and replacements are so subconsciously generated that any explanation would be nothing more than conjecture. Unfortunately I can't dance. If I could, I would launch into a tap routine at this point and declare it to be The Empire State Building.

Suffice it to say that all of my paintings are pictures of old friends that I am meeting for the very first time.

LETTING GO

"What do I want from this painting?" is a much smaller question than "What do I want from painting?"

The smaller question will see you through to the completion of a picture. Soon the configuration of the painting will become more finite and, likewise, the hopes and aspirations that urged its beginning. Eventually it will become all too apparent that changing one element would make it a totally different work. The time has come to step back, cross your fingers and hope that the painting can sustain itself as an independent and enigmatic object on a wall.

Out of the melancholy of this moment the larger question will arise. And the process will begin again.

I would love to be able to say that every second spent in the studio—every scratch, stroke, erasure, and smear—puts me incrementally closer to being an artist. That the integration of mind, heart and hand is inevitable through diligence. That Matisses and Picassos are made, not born. However it seems that rather than having a cumulative effect, each new picture holds the promissory note for complete re-education. And, if I am to make good on that note, I must posture myself accordingly; setting aside those confidences that cause as artist to imitate himself. Hopefully, a new and more informed confidence will emerge and, with that confidence, the courage to continue.

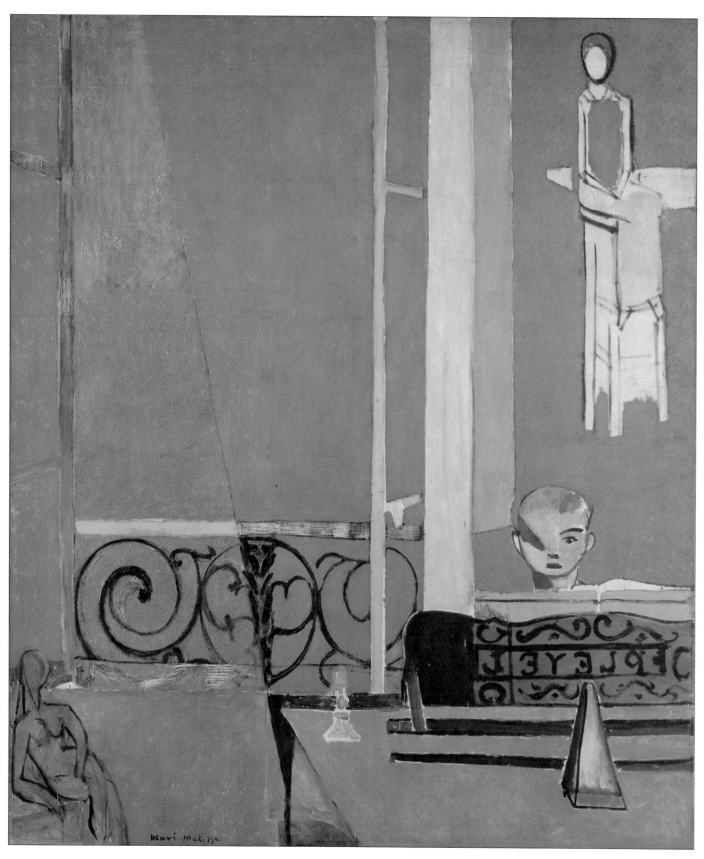

THE PIANO LESSON by Henri Matisse
Oil on Canvas 245.1 x 212.7 cms. 1991

can think of no single painting that has influenced my work as greatly as Matisse's *The Piano Lesson*.

When I entered art school in 1961, my knowledge of the world's great art was extremely pedestrian. I attribute this partially to parental apathy toward the visual arts. As I recall, there were no pictures in our house save those done by the children (mostly me) and the occasional framed photo of strobe-blinded family groupings. Art books were equally non-existent, and talk of art and artists beyond the scope and realm of my own fledgling efforts or Norman Rockwell's current *Saturday Evening Post* cover, though never avoided or dismissed as frivolous or irrelevant, simply never arose. As for my circle of teen-aged friends, suffice it to say the strength and delicacy of Rodin's watercolors were never the lead topic in post-football game locker rooms or cigarette-sneaking Saturday night cruises.

Consequently, the exposure to the visual arts that art school not only provided but encouraged was nothing short of mind-boggling. In retrospect, I liken it to that classic moment in *The Wizard of Oz* when the door of Dorothy's dismal and monochromatic bedroom opens on the emerald green wonderland and the yellow brick road.

Though I made no attempt to limit my exposure to any period or school of art, anything from the Lascaux cave paintings to Josef Albers' pulsating squares was given its day in court, I found myself increasingly drawn toward the works of Henri Matisse.

Though this gravitation was probably driven by nothing more sophisticated than "I don't know about art, but I know what I like," hindsight suggests that the deceptive simplicity of his work and the promise of accessibility and understanding that it afforded were a major motivation as well. I was hell-bent to learn picture making from the best picture maker I could find and the more I pored over examples of Matisse's work (all of this research courtesy of the school library's considerable resources), the more I reaffirmed my conviction that, by virtue of his astounding visual intelligence, Matisse was the most important painter of the twentieth century. An opinion that I hold to this day.

The simplicity that distinguished many of Matisse's works suggested to me that the basis of his extraordinary genius was a learnable theorem that would reveal itself as a reward for diligence, determination and patience.

To this end I chose *The Piano Lesson* as the focus of my quasi-scientific quest. Bold in its structure, dynamic in its use of brilliant, contrapuntal color and representational enough that a point of departure could be ascertained, it seemed the perfect "classroom." Needless to say, my arrogant and ill-founded pursuit was doomed from the outset. Despite

weeks of apish scribbling, hare-brained "analysis" and meaningless tracing paper diagrams, I came up empty. If any conclusion was reached it was that this apparently simple picture of a young boy practicing his piano under the watchful gaze of a female figure was extremely and impenetrably complex. Duly humbled, I abandoned the project.

II

Providence, Rhode Island, is a scant three hours from the formidable museums of New York City. For myself and my fellow painting students, however, a pilgrimage to the holy land was rare. No one had access to a car, and public transportation—not to mention the expense of overnight accommodation—cut mercilessly into funds earmarked for material, tuition, and rent. It was, therefore, some time after my "apprenticeship" to Matisse that I first visited the Museum of Modern Art—permanent home of *The Piano Lesson.*

It is impossible to take in the Museum of Modern Art in a day. Either you never make it past the first room—waylaid by a less than prominently displayed masterpiece that had previously escaped your attention—or you purposely allow yourself only the brief blasts of exhilaration that come with walking intrepidly past some of the most breathtaking objects on earth.

Knowing this to be the case, I thought long and hard about how I would handle my first visit—especially since I knew it could be a while before the next one. Thanks again to the school library, I had a cursory knowledge of the museum's collection. I also had the disgruntling awareness that, from time to time, vast sections of that collection can be on loan or in storage. And, the primary factor in my planning, I was more than aware that easily a dozen of my favorite Matisses were among the museum's treasures.

The Matisses were on an upper floor and, despite the frustration of having to give relative lip service to unanticipated marvels, as well as Monet's venerated *Water Lilies* and Picasso's *Guernica*, I took the stairs two at a time.

It was a large room and understandably crowded. There on the walls were *The Red Studio, The Dance, Nude With Goldfish*, drawings and sculptures—each example more devastating than the next and each so different from what the reproductions had led me to believe that I literally spun around the room in delirium.

It has been said that "God is in the details," and never has that been more apparent than in the works of Matisse. So engrossed was I that I barely took note of the fact that *The Piano Lesson* was not to be seen. What disappointment I felt (I simply assumed it was on loan) was easily erased by the joy of being so close to the exhibited work.

I cannot say for sure how long I roamed that room, rudely pushing my way to the front of tourist groups, and actually touching the canvas when the guard wasn't looking, but I recall feeling lightheaded enough that a few minutes out in the sculpture garden became a necessity.

Thinking I was on my way toward the stairs, I turned a corner and that's when I saw it. *The Piano Lesson* had been given a room virtually to itself and I found myself locked in its grasp like a deer in high beams.

I wonder if my reaction—one of confrontation rather than surprise encounter—would have been the same had I not spent so many hours obsessing over what I now saw was a postage-stamp sized reproduction of the eight-and-a-half-by-seven-foot original. I literally felt my knees go weak and luckily made it to the leather and chrome bench in the middle of the room where, my eyes still riveted on the painting, I imagine I boorishly edged some foot-sore out-of-towner back to his feet. I can't say for sure because all but the painting had disappeared from my consciousness, including the mutterings and the shufflings of the gallery-goers and guards.

Melodramatic as all of this may sound, I can honestly say that I was engulfed by a rapture that obliterated all reality save the canvas. And, as I sat there in my ecstatic state, the faint but unmistakable sound of a child's touch on the piano broke the silence. Honest to God.

III

It has taken me nearly thirty years to realize that my original, mistaken premise—that diligence, determination and patience could ultimately deliver up a painter's genius—was only slightly askew. The truth is that diligence, determination and patience can deliver up a specific painting's genius—that magical and intangible quality that enables a painting to make music.

Recently, I have attempted to tap the feelings that attended my first viewing of *The Piano Lesson* as inspiration for paintings of a similar subject. Although working from a pre-conception, even one as vaporous and esoteric as those memories, forces certain restrictions, I have made what I currently consider to be some of my better pictures. This is not to say that I have achieved what I set out to do. That is going to take a lot more diligence, determination, and patience.

CLOWNS
Pencil on Paper 10¼ inches x 8¾ inches 1990

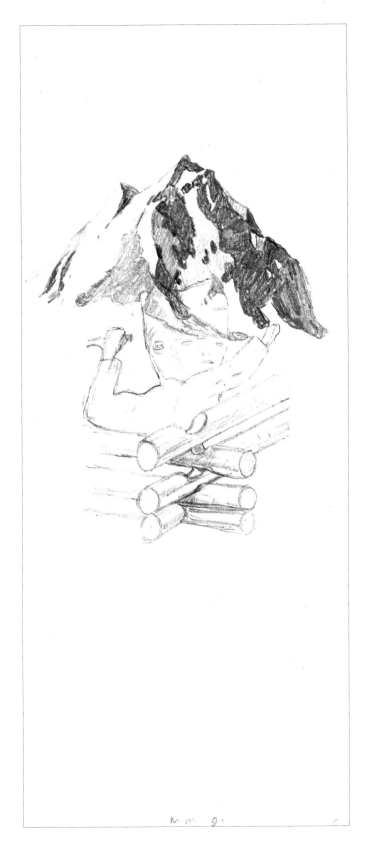

MOUNTAIN CLIMBER
Pencil on Paper 10 inches x 3¾ inches 1991

STUDY FOR STUDENT PAINTING
Pencil on Paper 6½ inches x 9½ inches 1991

NARCISSUS

Pencil on Paper 8½ inches x 7½ inches 1992

STUDY FOR ENCOUNTER
Pencil on Paper 6 inches x 7⅜ inches 1992

STUDY FOR THE DINNER GUEST
Pencil on Paper 7 inches x 6 inches 1992

STUDY FOR MILKMAN IN HEAVEN
Pencil on Paper 12½ inches x 8½ inches 1990

STUDY FOR BLUE FLAME
Pencil on Paper 4¼ inches x 6¼ inches 1992

STUDY FOR BEDROOM SCENE II
Pencil on Paper 5 inches x 6¼ inches 1992

STUDY FOR BEDROOM SCENE I
Pencil on Paper 9¼ inches x 6 inches 1992

STUDY FOR DEJEUNER SUR PATIO
Pencil on Paper 6 inches x 8 inches 1992

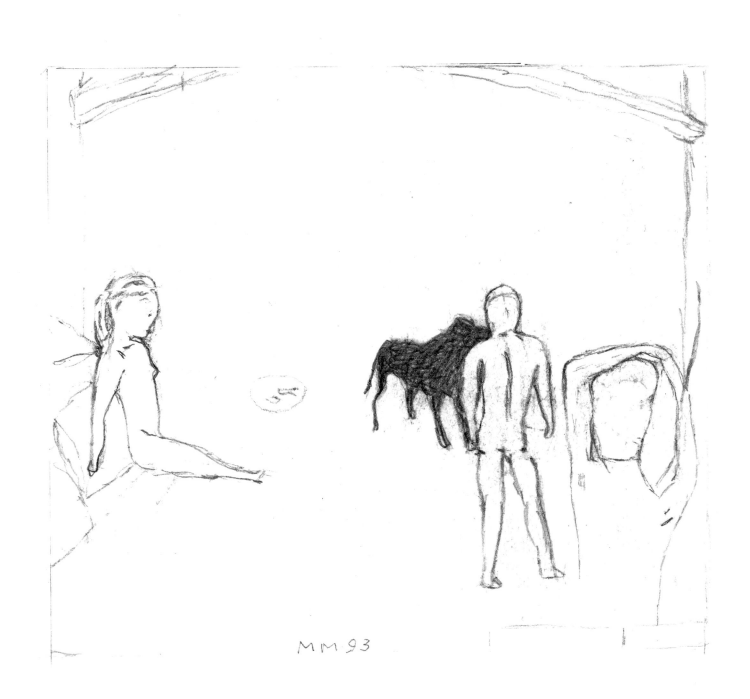

INDOOR/OUTDOOR
Pencil on Paper 6 inches x 7 inches 1993

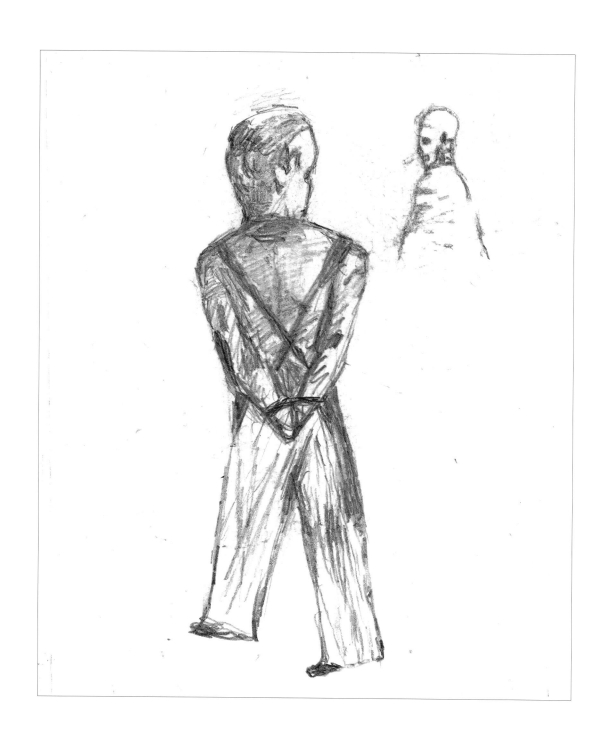

STUDY FOR CROSSING II
Pencil on Paper 6¾ inches x 5⅞ inches 1994

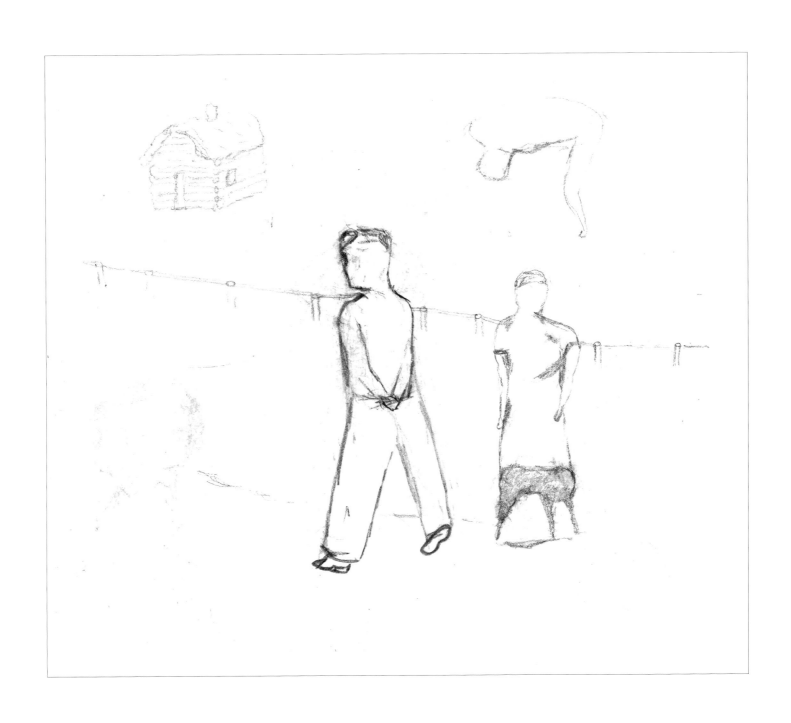

STUDY FOR CROSSING III
Pencil on Paper 9½ inches x 8¾ inches 1994

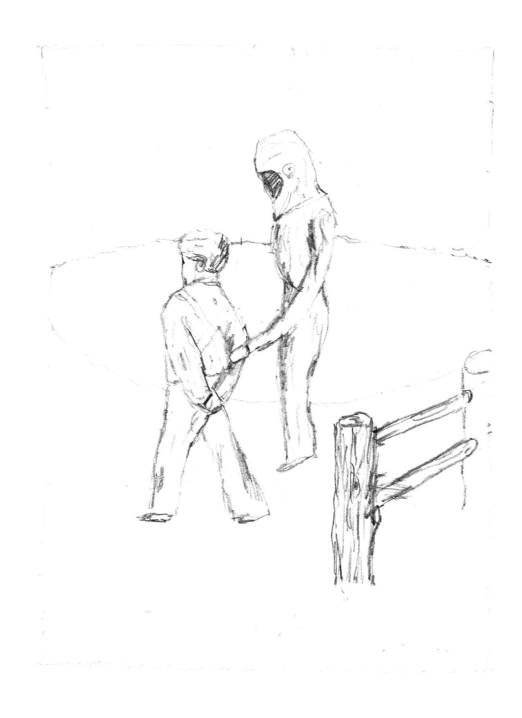

ABDUCTION
Pencil on Paper 6½ inches x 5 inches 1993

ON ORIGINALITY

At the risk of deporting myself to that far pasture society reserves for Old Farts, I would like to say a word or two about originality. Namely: it's not what it used to be.

In the mass-production marketplace, where injecting anything with "the scent of real lemon" qualifies as a watershed in the evolution of Western civilization, originality has been sanctified to the point where it is no longer a quality that something may possess, but the thing itself. Beer becomes "lite" beer becomes "Gimme a lite." One would assume, however, that the world of Fine Art, by virtue of its inherent and historically founded morality, would be immune to such "new for new's sake" frivolity. But a quick flip through any contemporary art magazine (or certain recent museum annuals and national biennials, for that matter) seems to indicate otherwise.

Now don't get me wrong. I'm a firm believer in pushing the boundaries and the first to say Amen to virtually every cliché from "Rules are meant to be broken" to "Go West, young man." It's just that I find it somewhat astounding that, seemingly overnight, so many would-be painters have flung themselves into the innovation-obsessed worlds of "installation artist" and "performance artist"—abandoning the whole notion of applying paint to canvas as either "too limited" or an exhausted and passé mode of expression. First of all, I can't help but think that the "limitations" of which they speak are the very life-giving and potentially life-consuming challenges that painting uniquely possesses—challenges that have survived for centuries and remain as provoking and enigmatic today as when that first mono-browed caveman studied the cracks in his wall. Secondly, if it can be argued that Art as concept grows out of "the human condition," then it stands that every subsequent work is now an integral part of the current collective unconscious. As such, painting is constantly re-inventing itself, thereby obviating any risk of having its possibilities exhausted. Likewise, this ongoing redefinition allows for a continued and vital relevance.

If, as I suspect, it's the brass ring of originality that has lured so many into the areas of installation and performance art, then I am all the more dumbfounded as to why so many of these supposedly inventive and heroically proportioned pieces look alike. Perhaps it's a school, not unlike Fauvism or Cubism, and I'm too old and stodgy to pass the entrance exam. Nevertheless, I still anticipate with horror the possibility that one day art stores will stock nothing but beeswax, powdered pigment, chicken wire, dance belts, and strobe lights.

Although I find most installations and performance work to be a little less satisfying than a rummage sale or school play, respectively, nothing is more annoying to me than those works that attempt to be "cutting edge" by embracing current social and political

issues. Two quotes come to mind that pretty much sum up my feelings on the subject: "Messages should be sent by Western Union"—Samuel Goldwyn; and, as a review of a deservedly short-lived Broadway play entitled *For Our Time Only,* "Not timeless enough"— Alexander Woollcott.

So, what do I like? I like the fact that, without leaving the confines of paint on a rectangular surface, monumental and extraordinarily original work by such masters as Picasso, Matisse, Rothko, Pollock and de Kooning, to name only a few, has been created in the last fifty years alone! When the entirety of art history is considered, this flurry of discovery can only indicate that many doors are left to be opened. And, since I firmly believe that originality is the accidental by-product of honest and dedicated introspection, I like the fact that a ground swell of interest has recently arisen as regards "Outsider Art."

Perhaps this newfound, critical appreciation of Outsider Art—highly personal, often visionary, and always charged with the feeling that the artist was helpless not to create it— is a response to the inaccessible, anonymous, and frequently sophomoric work that passes for the avant garde. Perhaps it is simply because these painters have more on their minds than trying to be original—in fact, I doubt that the notion has ever occurred to them.

After thirty-some years of painting, I have come to the conclusion that being original is of no consequence when compared to being honest. However, if the pabulum served up in all of those self-help paperbacks is true, and we are all, indeed, as "different as snowflakes," then, perhaps, hard work and the pursuit of an ultimate honesty may provide for some originality down the line. In the meantime, I'm not going to worry about it. Instead, I'll bear in mind something that I believe Jean Cocteau once said: "one has to be very careful with originality or one may appear to have a brand-new haircut and a brand-new suit."

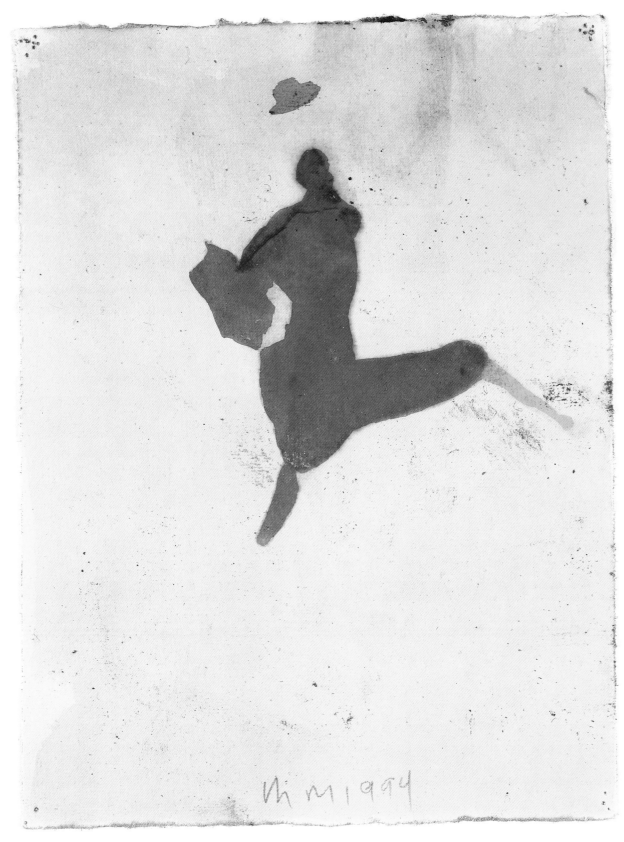

BUSINESSMAN
Pencil,Watercolor, and Ink on Paper 9 inches x 6¾ inches 1994

100 THINGS TO DO

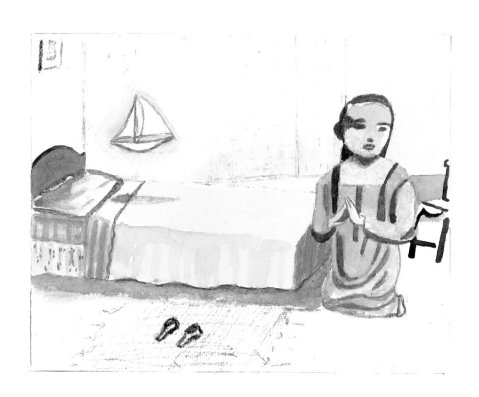

100 THINGS TO DO
Watercolor and Pencil on Paper 10½ inches x 8½ inches 1992

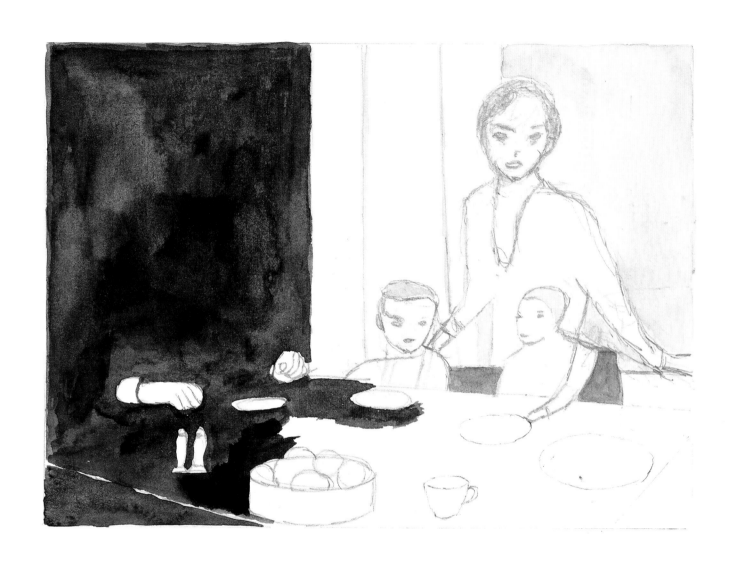

STUDY FOR THE DINNER GUEST
Ink and Pencil on Paper 5 inches x 7 inches 1993

BLUE LADY, SEASIDE
Watercolor and Pencil on Paper 7½ inches x 5¾ inches 1993

PRAYERS
Watercolor and Pencil on Paper 6¾ inches x 8¼ inches 1993

NEW YORK FALL I
Ink on Paper 10½ inches x 8¾ inches 1993

NEW YORK FALL II
Oil and Chalk on Paper 22¼ inches x 30 inches 1994

HEAD AND FIGURE
Chalk on Paper 22½ inches x 22½ inches 1994

TWO FIGURES
Chalk on Paper 22½ inches x 30 inches 1994

SEASIDE ROMP
Watercolor and Collage on Paper 8 inches x 10 inches 1994

STUDY FOR HARMONY OF DISAGREEMENT
Oil, Watercolor, and Collage on Paper 14¾ inches x 18 inches 1994

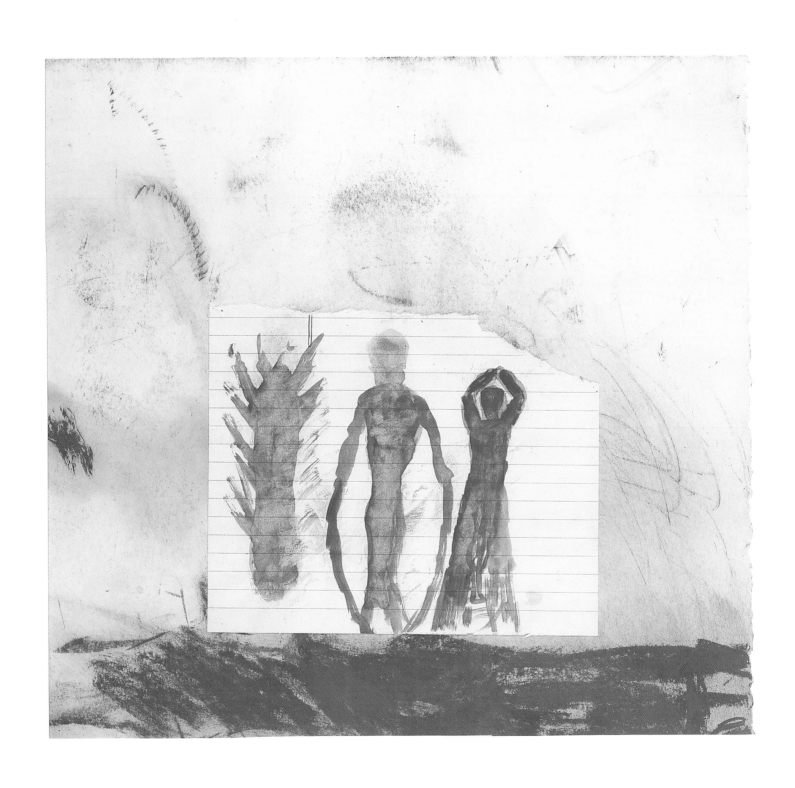

STUDY FOR ADAM AND EVE I
Chalk, Collage, and Watercolor on Paper 14 inches x 15 inches 1994

50

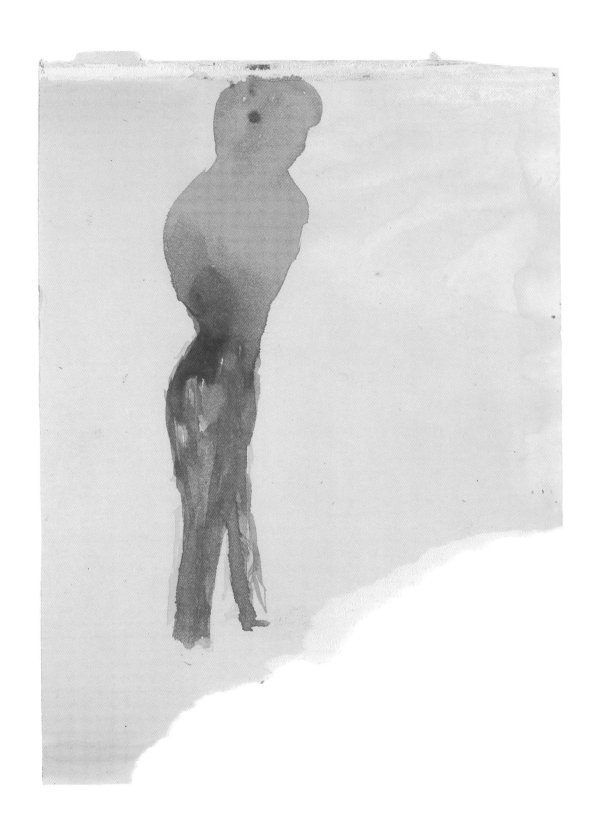

STANDING MALE
Watercolor and Ink on Paper 7 inches x 5 inches 1994

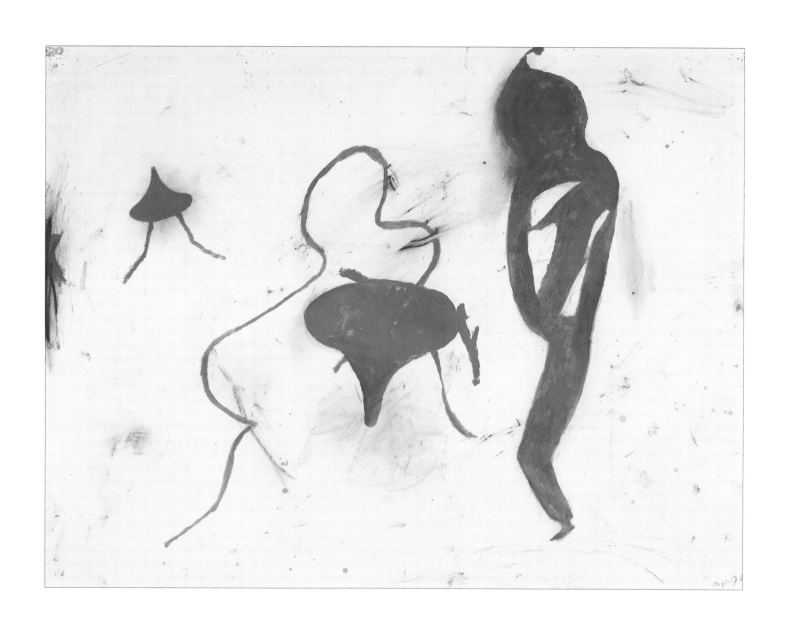

ALIEN
Oil and Chalk on Paper 22¼ inches x 30 inches 1994

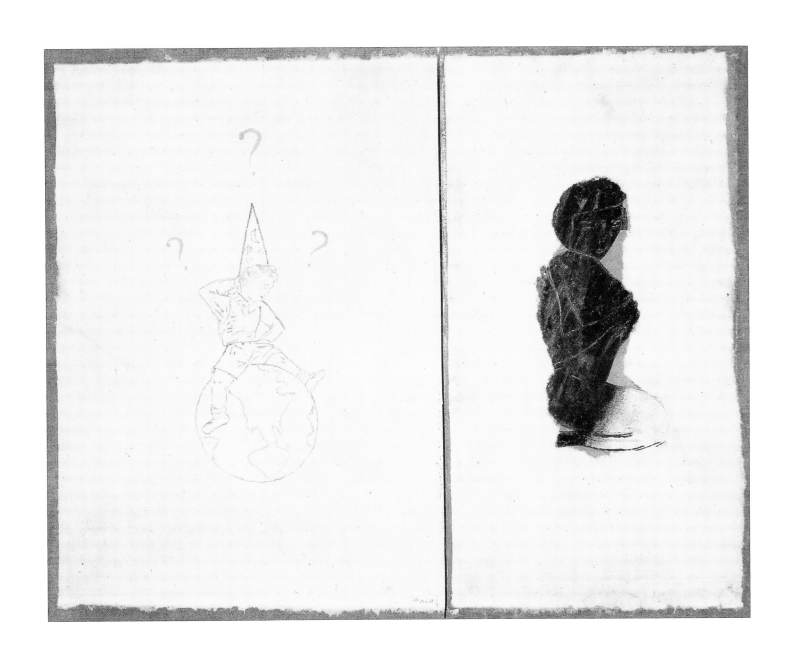

PAGES FROM A MARRIAGE MANUAL
Ink, Chalk, Watercolor, and Collage on Paper 18 inches x 23 inches 1994

STUDY FOR WIND CHILL
Watercolor on Paper, Mounted on Leaded Wood 20 inches x 14½ inches 1994

LUCY
Ink on Paper 6¼ inches x 9 inches 1994

FAMILY GROUPING II

Ink Wash on Paper 8½ inches x 14 inches 1994

SEATED FIGURE
Watercolor and Pencil on Paper 11½ inches x 8 inches 1994

had a friend in art school who wanted to be Vincent Van Gogh. He dressed like him, brooded and ranted like him, and, most importantly, did everything in his limited power to paint like him. So intent was he on becoming the two-eared reincarnation of the bedeviled Vincent that I was totally taken aback one day to hear him complain, to our professor, no less, that he was having difficulty finding his own style. Initially, the professor was as surprised as I since our friend had given no indication that he was anything but giddy about the prospect of a tormented life filled with muddy, scumbled portraits of old brown shoes. The student, however, launched into a diatribe that eventually convinced the professor that imitating Van Gogh was the last thing he wanted to do. Satisfied, the professor suggested a course of action that I found worthy of Solomon: The school museum had a small Van Gogh landscape on permanent display. My friend was to take his paint box into the museum, set up his easel and copy the painting as faithfully as he could. Needless to say, my friend was perplexed as to how this assignment could be anything but diametrically opposed to his need for individuality. The professor simply smiled and told him "everything you get wrong is *your* style."

When style becomes anything but the unplanned child of intent and limitation it reduces the work to nothing more than self-conscious decoration.

This malediction, unfortunately, is not the deterrent that one would hope. There are still many profit-driven "stylists" whose works dominate the print and poster bins at the shopping-mall frame shops (certain "sports figures," "soft-core S&M," and "optical illusion" artists immediately come to mind); however, there is no mistaking their mass-produced efforts as anything other than the decorative accessories of the culturally challenged.

So why, with the threat of being included in the company of these charlatans hanging like the sword of Damocles, would any self-respecting artist risk being even remotely concerned with style? I can only speak for myself, but I suspect that there is a somewhat universal need among artists to have their work perceived as unique, and having a recognizable style is an expedient means to this end.

Whenever I have mounted a gallery or museum exhibition, I have always been concerned as to whether the selection and grouping of the pictures indicated a contiguous and focused effort. That the show have a "look" if you will. This concern is prompted by the certainty that a showing of seemingly disparate works will evoke cries of "dilettante" and "Sunday duffer" from those who know me primarily as a show business figure.

As the illustrations in this book demonstrate, my work has changed drastically over the past thirty years—to the point that a retrospective exhibition could be easily mistaken

for a "group" show. Much of this bouncing around can be attributed to "growing pains." A still larger factor, I fear, has been the gnawing and frustrating need to "arrive" as an artist; to have a well-defined arena and vocabulary of expression that would enable me to commence a "life's work."

I have since come to the painful realization that "arrival" is not something that can be assumed or artificially manufactured. On the contrary, jumping on a bandwagon such as photorealism or presuming a position of anything but student in an already existent mode of expression roadblocks the growth and introspection that will sponsor honest arrival—if, indeed, honest arrival is destined to happen, and there is always the very real chance that even a lifetime of hard work can come up "no cigar."

Lately, through a concerted effort to disallow myself whatever skill and facility I possess—thereby reducing the frequency of glib and unsatisfying answers—I have become aware of a certain "handwriting" that reappears in the work. It's conceivable that this stamp is the long-awaited light at the end of the end of the tunnel. At the age of fifty, it wouldn't be terribly premature. However, to concentrate on its development or, worse yet, coax it into some "grande œuvre" would doubtless prove counter-productive. After all, since my goal is to simply put down what the picture itself demands to be, this "handwriting" could be merely the parts I got wrong.

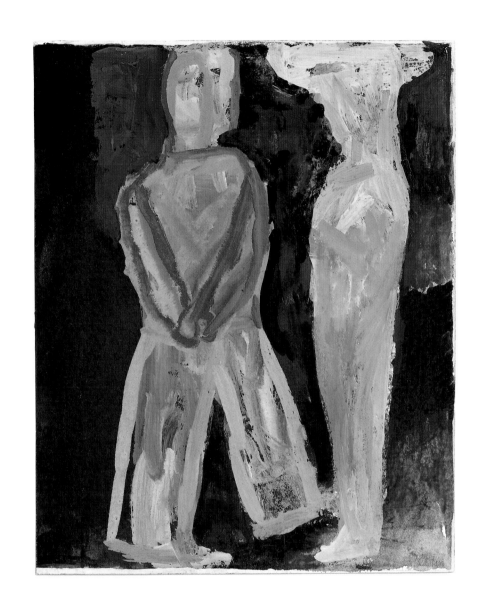

MEXICANS
Watercolor on Paper 5½ inches x 4½ inches 1994

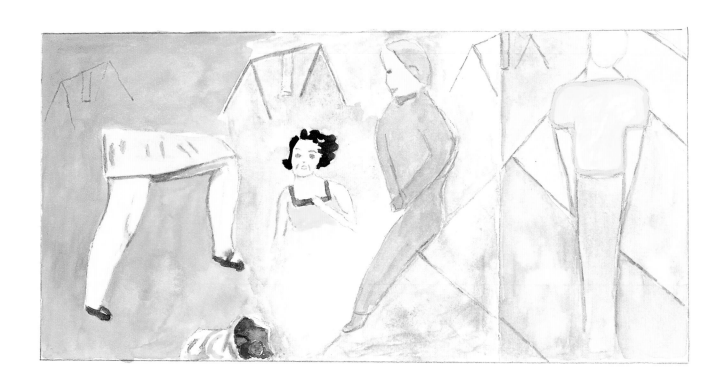

PLAYGROUND
Watercolor on Paper 3½ inches x 7 inches 1992

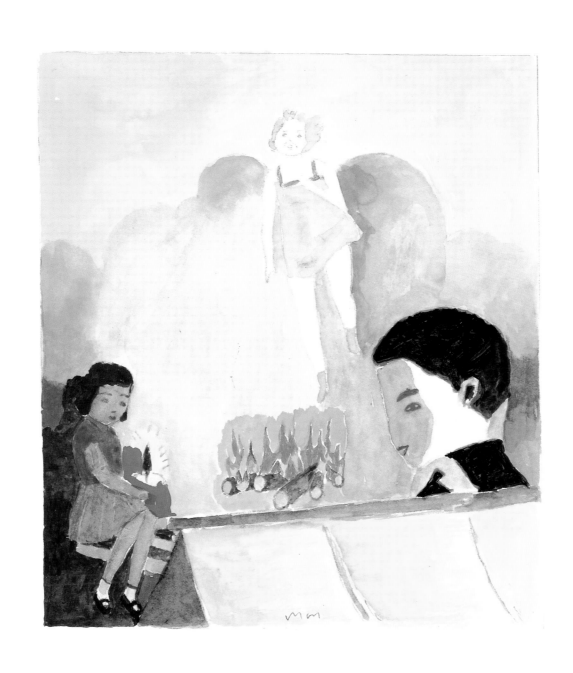

CAMPSITE
Watercolor on Paper 6 inches x 5½ inches 1992

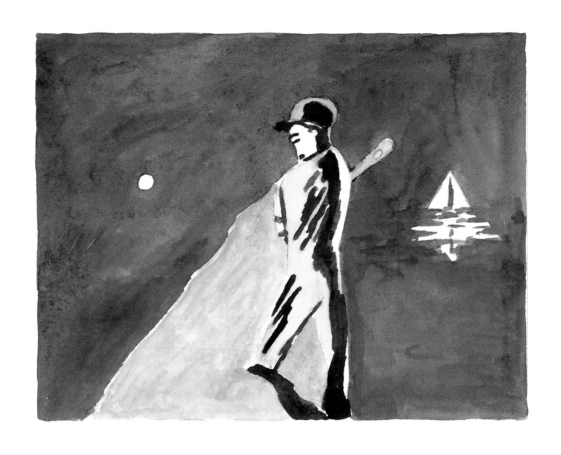

STUDY FOR JAPAN
Watercolor on Paper 4 inches x 5½ inches 1992

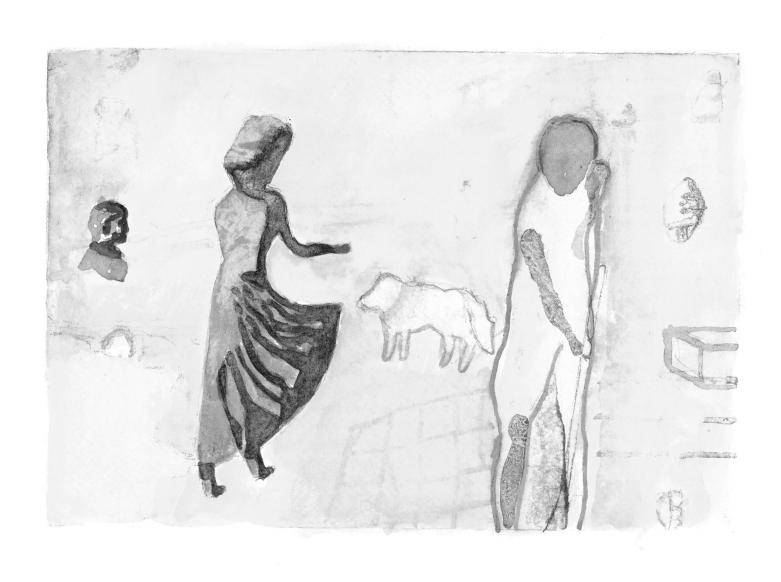

STUDY FOR WHITE DOG

Watercolor on Paper 5 inches x 7½ inches 1993

CHRISTMAS FALL
Watercolor on Paper 5¼ inches x 7½ inches 1993

EASTER ISLAND II
Watercolor on Paper 7½ inches x 7 inches 1994

COUPLE
Watercolor on Paper 5¼ inches x 5 inches 1993

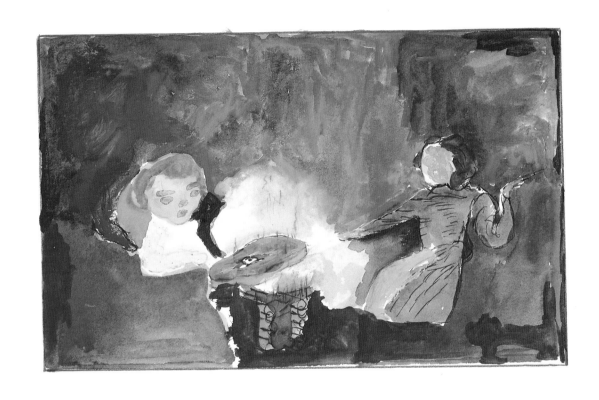

HAZEL'S COOKOUT
Watercolor on Paper 3½ inches x 5¾ inches 1993

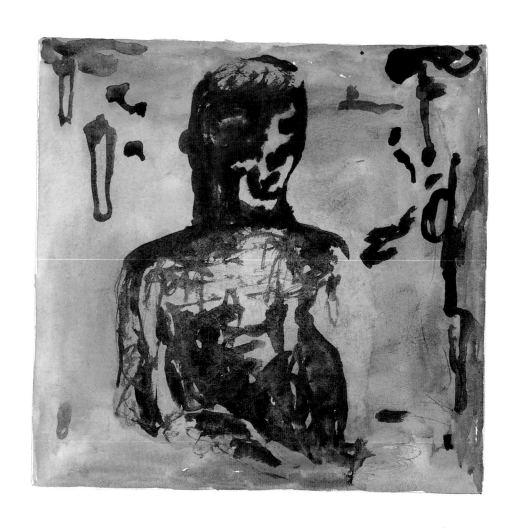

YELLOW AND BLACK PORTRAIT
Watercolor on Paper 4¾ inches x 4¾ inches 1994

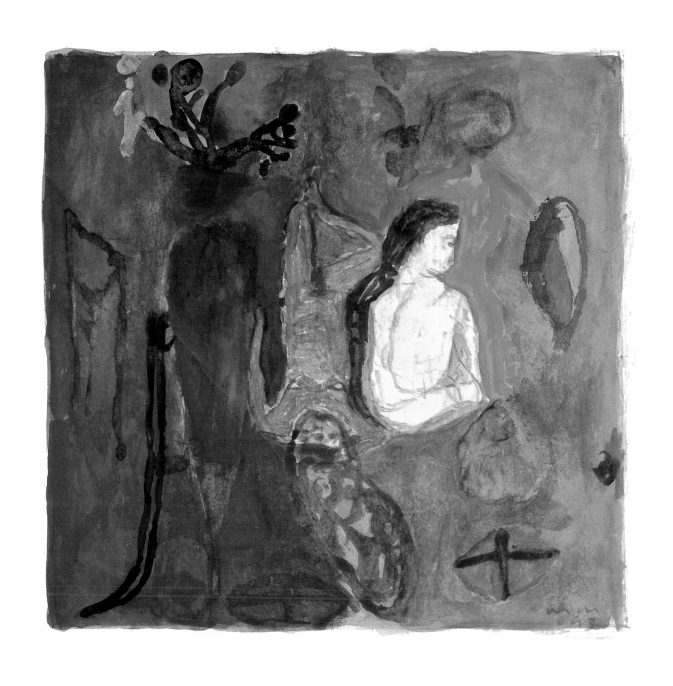

WINTER'S BATHERS
Watercolor on Paper 6¼ inches x 6 inches 1993

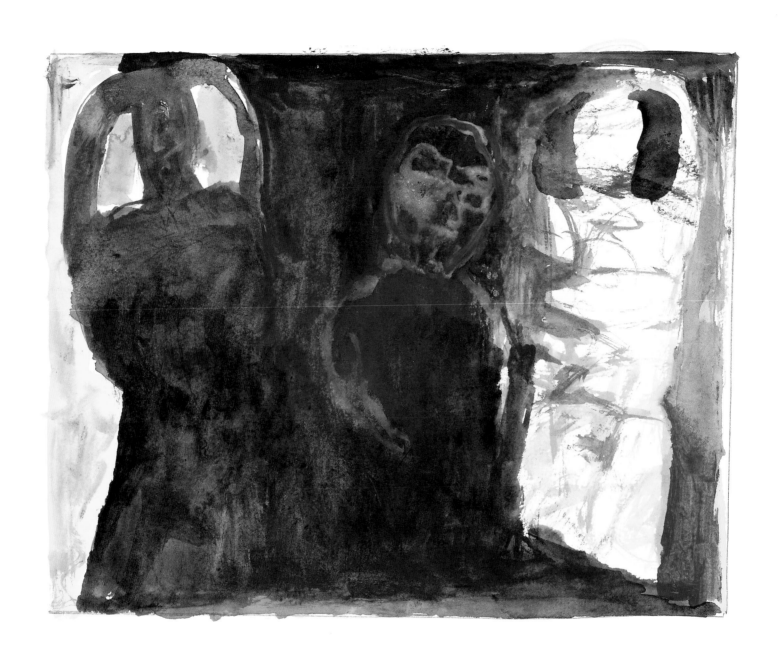

THREE BATHERS
Watercolor on Paper 5¾ inches x 7½ inches 1994

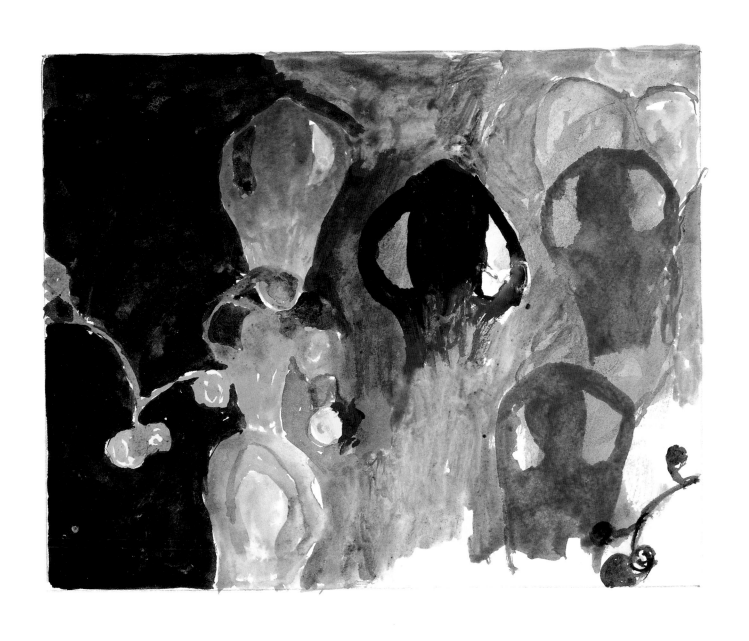

FIVE BATHERS
Watercolor on Paper 5¾ inches x 7 inches 1994

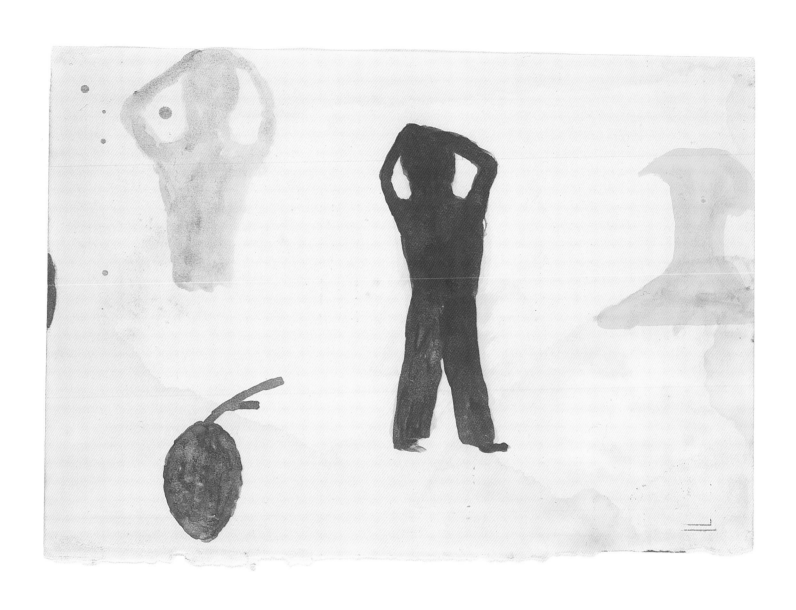

STUDY FOR BATHERS BY A RIVER
Watercolor on Paper 6¾ inches x 9¾ inches 1994

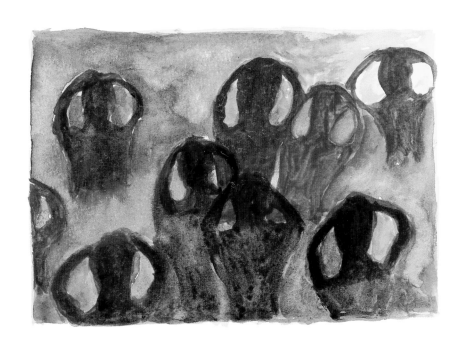

NINE BATHERS
Watercolor on Paper 3 inches x 4½ inches 1994

sometimes spend a whole evening in my studio just taking visual inventory. As studios go, it's not particularly large, small enough, in fact, that I can anchor myself on my trusty old, dog-stained couch and, with a minimum of contortion, have an unobstructed view of any of the works that virtually cover the four walls—finished paintings, paintings in glaring want, drawings, scraps of drawings, and masterpieces from the hand of my eight-year-old daughter. In many ways it's like going to a family reunion. There is the necessary adapting to a specific and coded familial vocabulary, the melancholy of re-living previous accomplishments, now diminished in importance by time and, hopefully, the chance of discovering unique and exciting qualities in a "family member" that had been all but written off.

Time spent interrelating with my pictures—both finished and in progress—also serves as a debriefing, a "town meeting" of sorts with much give and take, wherein the topic of discussion is always the same. Namely: Who am I and what am I trying to do? The pictures know me only as the painter and can converse with me only in those terms. Speaking in their language forces me to eliminate the incomprehensible and irrelevant from my end of the conversation and stick to the visual issues. Doing so also helps me to better understand how the paintings interrelate and converse with each other. Sitting in silent witness to the cross-talk between those pictures on my walls—impulsive, spontaneous, free-for-all exchanges wherein visual elements of one work are offered up to another and vice versa—has been the source of some of the clearest directives my work has received.

Needless to say, if the relationships between those works displayed is as potentially fruitful as I maintain, then the placement of the pictures on the studio walls is as critical as the arrangement of elements within each picture. For this reason, what I choose to look at is in a constant state of rotation and reconfiguration. My studio is as much a gallery as it is a workplace. It is a gallery in both the traditional sense and, in the heat of battle, a gallery like those found in an operating theater or, considering the extent to which I feel a judgmental presence, a courtroom. When working on a new painting, I often find myself checking with those other works in the room for validation and guidance. In essence, these not-so-silent partners—especially those that have passed muster as finished works—are my compass.

They are also my friends, capable of varied opinions, representative of disparate attitudes and aspects of reality, and as faithful as dogs. During those periods immediately preceding a new gallery showing, when the Sturm und Drang of pre-show activity subsides and the order of the day is the compulsive puttying of distracting nail holes, the re-painting of studio walls and the "acid-test" hanging of works about to leave the studio, I often feel

an extraordinary sadness. A sadness tinged with a generous helping of anxiety as to whether "my babies" can survive outside the womb. Safely sheltered on my studio walls, the "graduates" appear to me as valid efforts. But how much of this validity is in my eyes alone? To what extent is my intense knowledge of their inner workings and their aspirations the deciding factor in their worth, their life-support system as it were? These are questions that can only be answered by someone other than I, a realization that I accept with not a little unease since at no time during the entire painting process have I been concerned with communicating to anyone but myself.

And so, despite great anxiety and fear, and in the face of a natural possessiveness. the pictures leave my studio. They are now objects, consigned to foreign walls, open to the public and assigned a monetary worth. Since I am not, like many painters, solely dependent on my paintings as a source of income, I tend to wrestle with mixed emotions on the subject of selling. There is, I must confess, a strong desire to sell the work, a desire born out of the notion that sales equal validation and indicate that the work, in fact, does communicate. However, no sooner am I informed by the gallery that "so and so is interested in such and such a piece" than the second wave of emotion rears its head. My "artist" card has been punched and now I want to know "Who?" It isn't a case of chauvinism, more a fingers-crossed hope that the new owner will give the piece a good home. Neurotic and self-aggrandizing as this may seem, I am helpless not to see the transaction in the same light as marrying off a daughter.

News of an impending sale also gives rise to a shift in attitude, which I don't totally understand. I am sure that the explanation lies somewhere in the imprinting we all receive as members of a capitalistic society. Whereas I previously harbored anxious doubts as to the worth of the piece in question, I now feel that the gallery and I have undervalued the work. Coupled with this doubt is the pang that I may never do anything of such worth again, a pang that is only slightly assuaged by the knowledge that I "own the factory." None of this would be a problem if the value of the art, as with other over-the-counter merchandise, was determined by the cost of materials and going-rate labor. Ultimately, and gratefully, it is the gallery who becomes the final arbiter in such matters. Were it left to me alone, I would be hard-pressed not to base my decisions on an incident that occurred over thirty years ago:

As a third-year art student at the Rhode Island School of Design, I secured the position of dormitory monitor as a means of striking the word "rent" from my list of expenses. One of my thirty-some boarders was a graduate student in print-making from Japan named Hiroshi Murata. One evening as I was dutifully delivering his weekly allowance of bed linen and towels, I was treated to a look through his portfolio. There was one color etching that I particularly liked. Hand-to-mouth as my existence was in those days, I was not in the habit of buying art. However, assuming that Hiroshi was every bit as destitute as the rest of us, I dug deep and made what I considered to be the magnanimous offer of twenty-five American dollars. An awkward silence ensued, after which Hiroshi mustered his broken

English enough to politely inform me that my unacceptable offer was off to the tune of several hundred dollars—a figure which, at the time, was reserved for such things as a full-year's tuition or buying a home. Stunned and more than a little embarrassed, I muttered some sort of sheepish apology, set his towels on his bed and slinked toward the door where he stopped me with a forgiving smile.

"What you have asked me for is my treasure," he said. If you want me to give you my treasure, you must give me yours." I shook his hand, thanked him, and headed down the hall, having no idea that I would never forget his wisdom.

PLATES

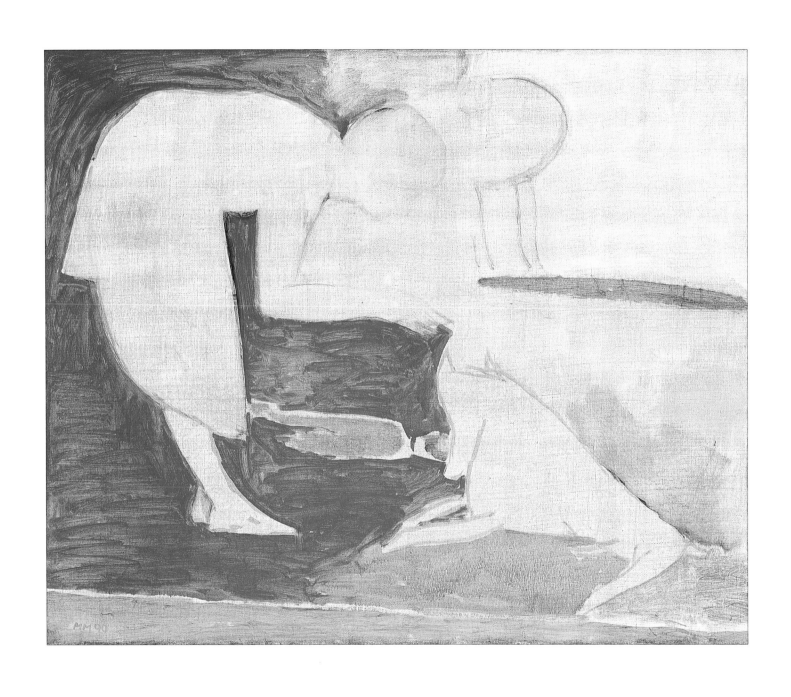

BAD DOG, GOOD CARPET
Oil on Linen 19¼ inches x 24 inches 1990

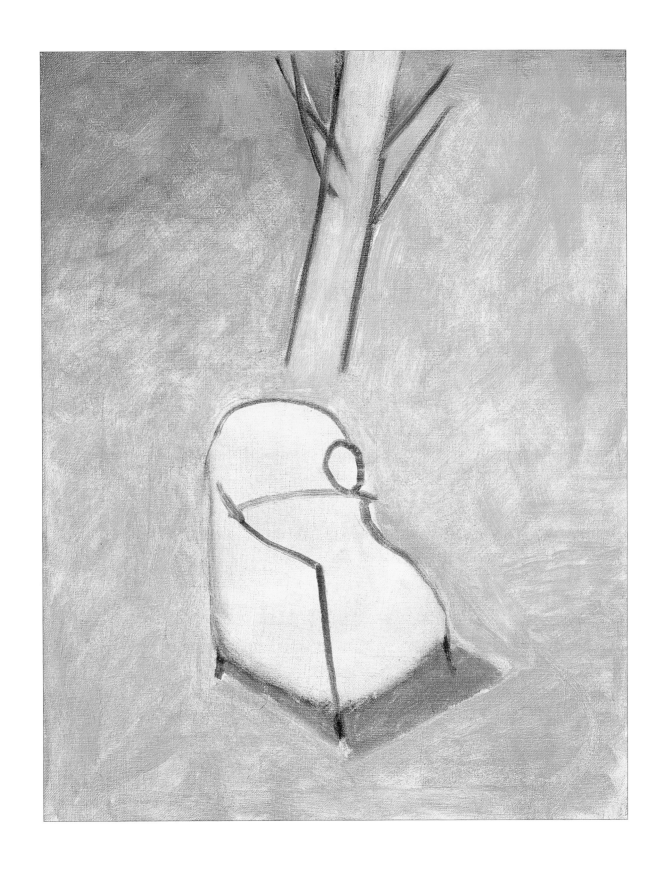

ABANDONED CHILD IN PARK
Oil on Linen 18 inches x 14 inches 1990

MILKMAN IN HEAVEN
Oil on Linen 54 inches x 21 inches 1991

NAIVE MODEL
Oil on Linen 72 inches x 60 inches 1991

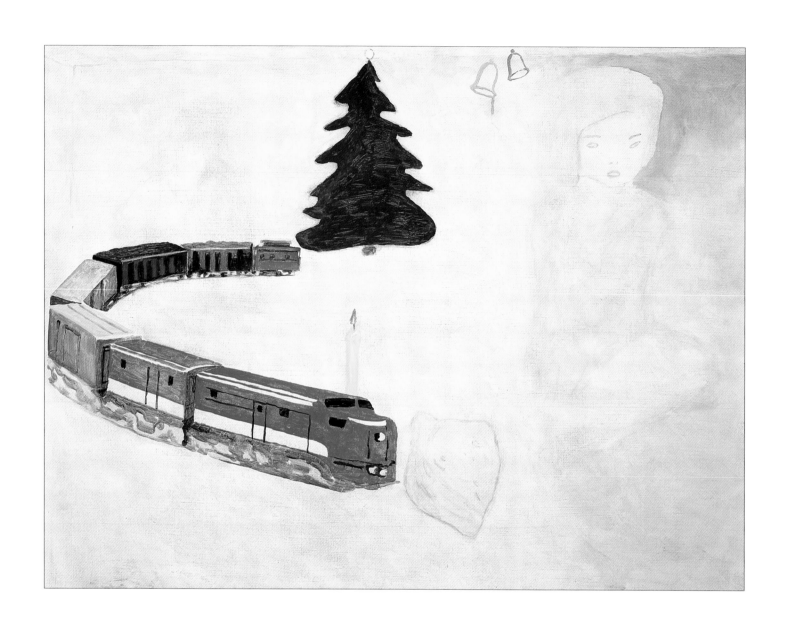

(UNTITLED) CHRISTMAS
Oil on Linen 35¾ inches x 48 inches 1992

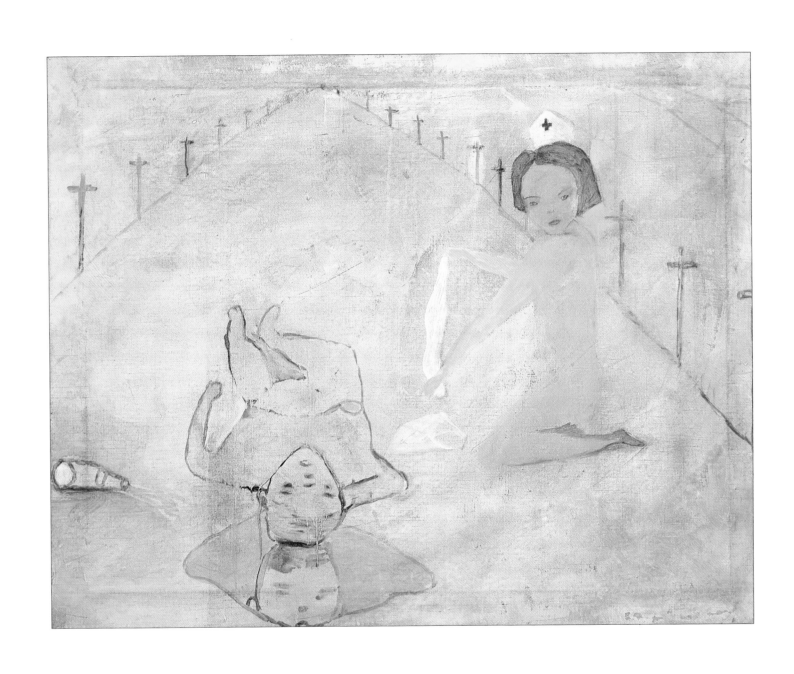

DRUNKARD'S DREAM
Oil on Linen 23½ inches x 29½ inches 1992

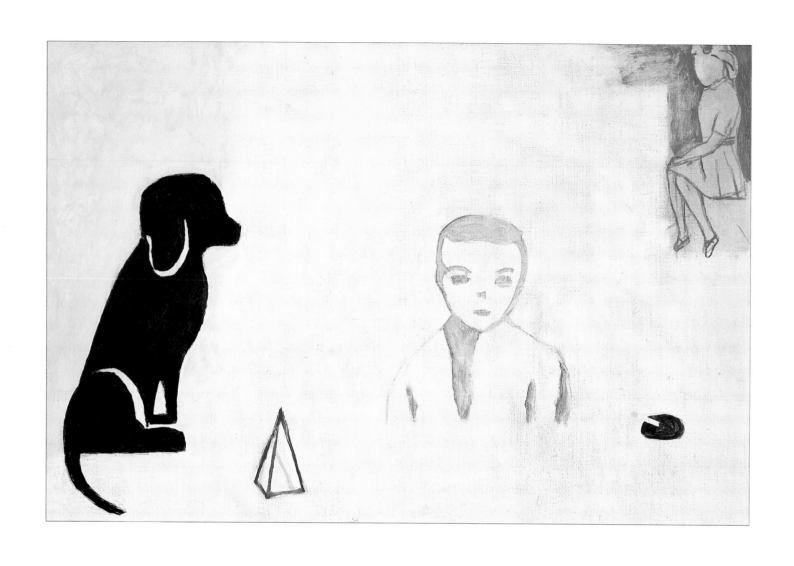

THE PIANO LESSON
Oil on Linen 24 inches x 36 inches 1992

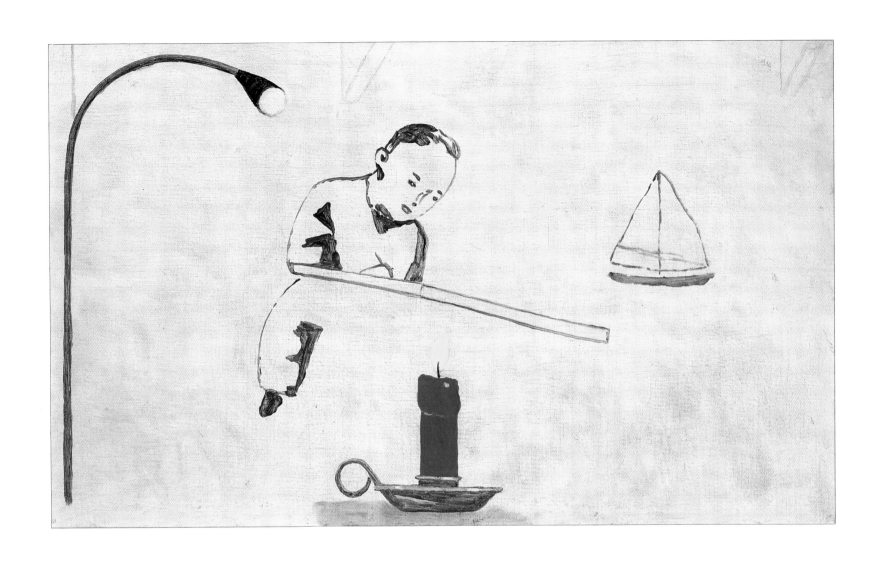

EDWARD HOPPER WORKING LATE
Oil on Linen 27 inches x 45 inches 1992

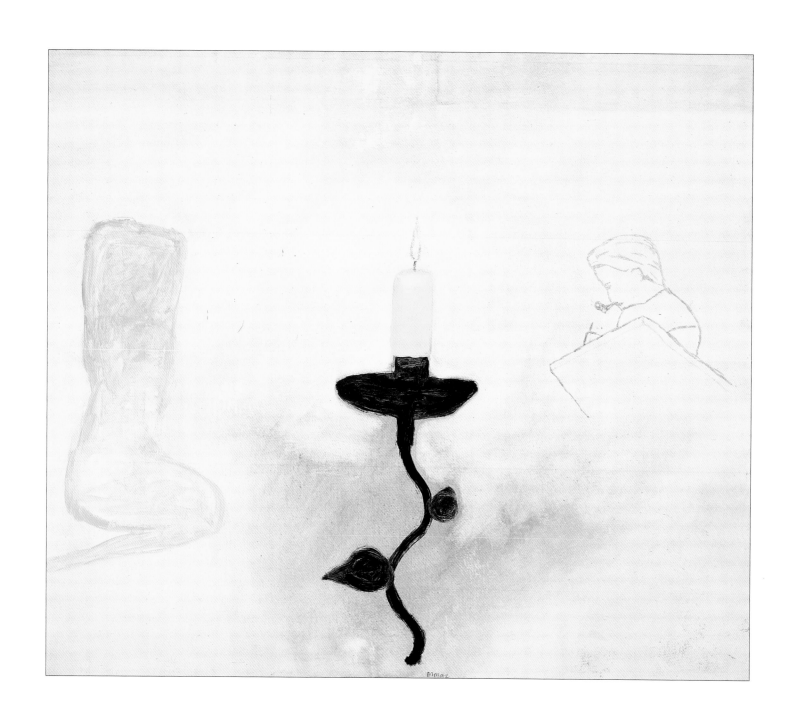

BLUE FLAME
Oil on Linen 24½ inches x 28½ inches 1992

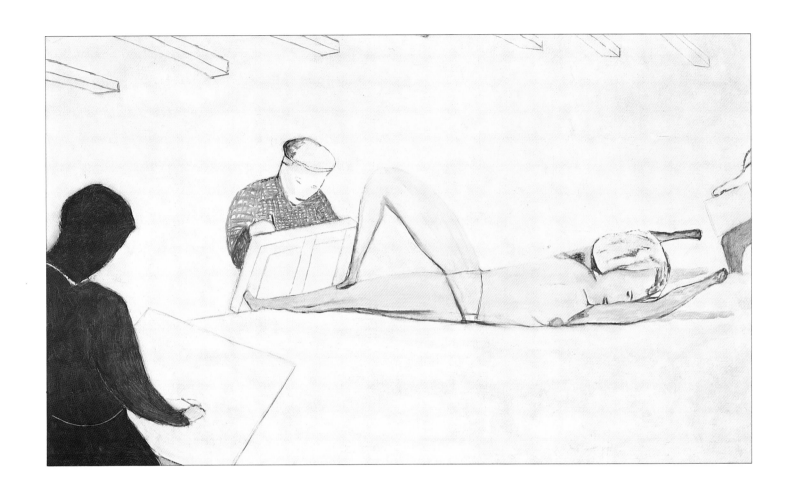

STUDENT PAINTING
Oil on Linen 49¼ inches x 82 inches 1992

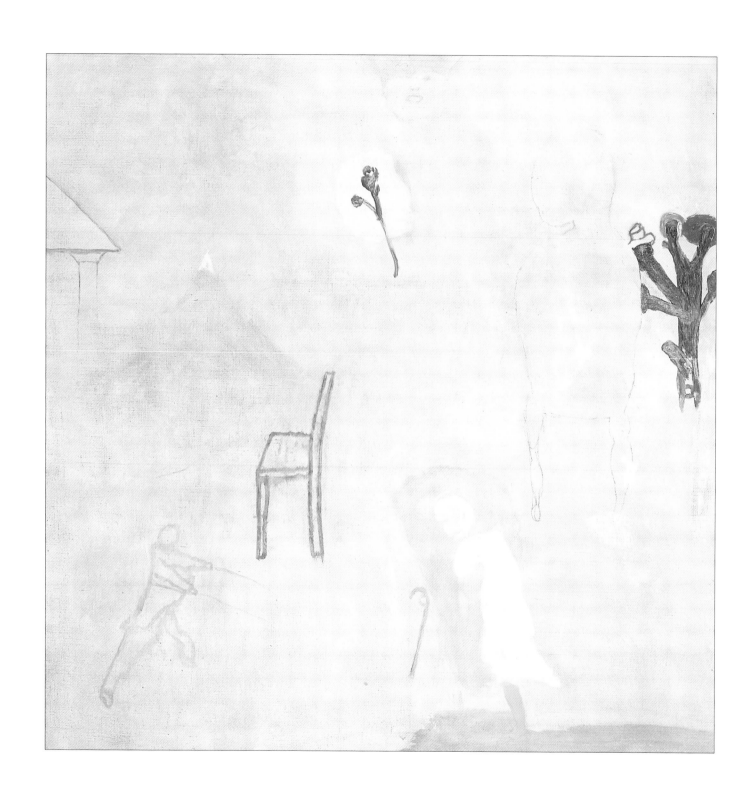

MYTH OF SISYPHUS
Oil on Linen 36 inches x 36 inches 1993

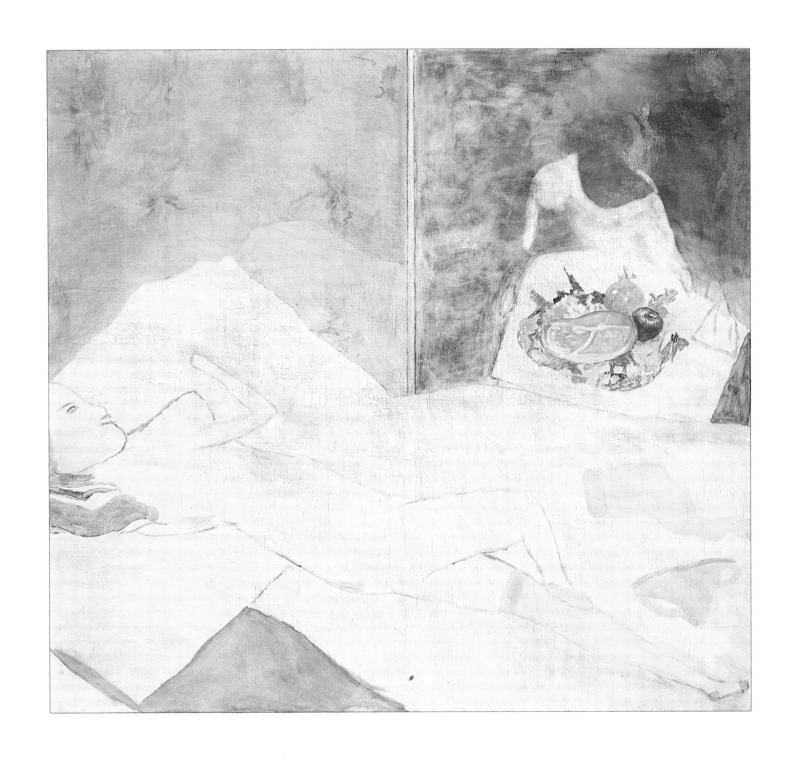

OLYMPIA
Oil on Linen 49¾ inches x 56 inches 1992

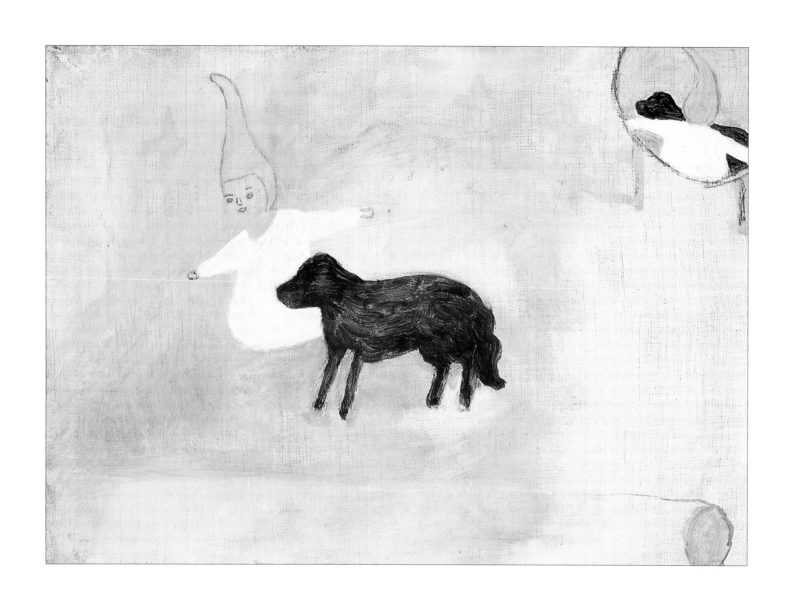

DOG DREAM
Oil on Linen 10 inches x 14 inches 1993

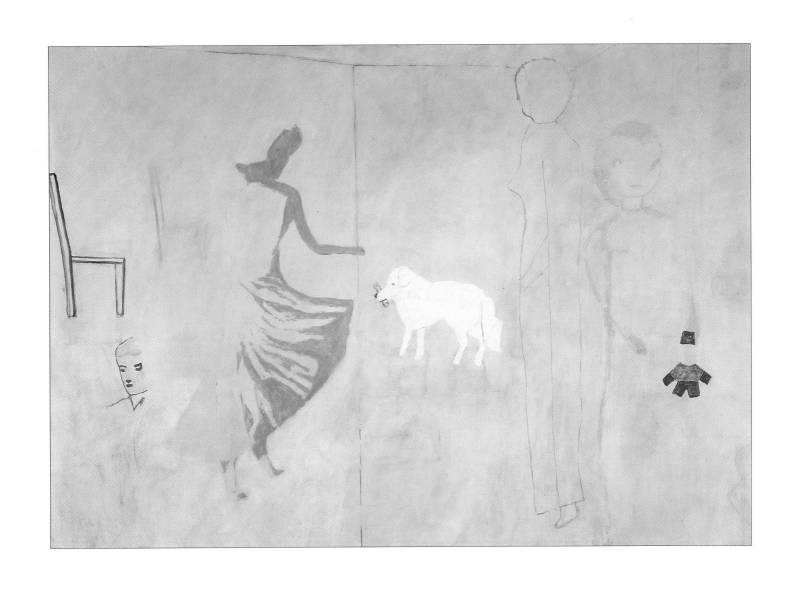

UNTITLED (WHITE DOG)
Oil on Linen 62 inches x 87 inches 1993

BALLGAME
Oil on Linen 11 inches x 14 inches 1993

SIZZLER
Oil on Linen 10 inches x 14 inches 1993

DEJEUNER SUR BEACH
Oil on Linen 10 inches x 14 inches 1993

AT THE BLACK DOG CAFE
Oil on Linen 56 inches x 82 inches 1993

CHRISTMAS EVE
Oil on Linen 53¼ inches x 73¼ inches 1993

EASTER ISLAND
Oil on Linen 20 inches x 16 inches 1993

SEANCE
Oil on Linen 24 inches x 30 inches 1993

BEDROOM SCENE
Oil on Linen 61¼ inches x 74½ inches 1992

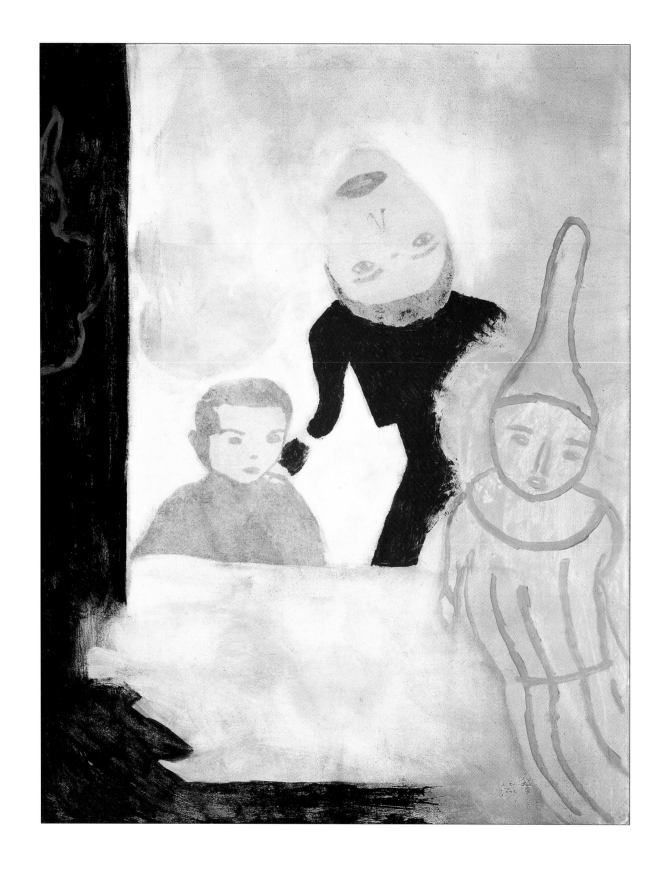

THE DINNER GUEST
Oil on Canvas 40 inches x 30 inches 1993

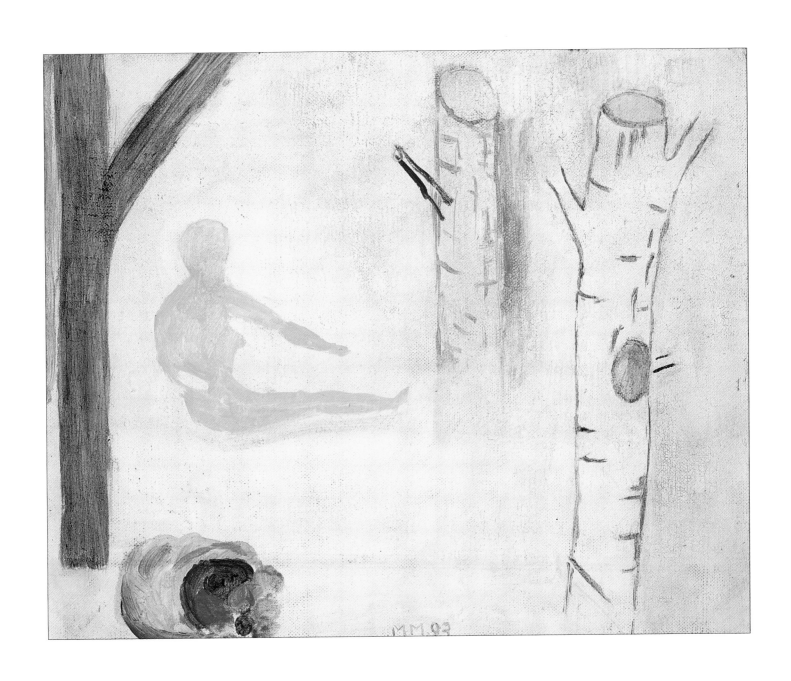

WINTER FALL
Oil on Linen 11 inches x 14 inches 1993

TRYST
Oil on Linen 44 inches x 50 inches 1993

O'CLANCY HAD A THING FOR REDHEADS
Oil on Linen 60 inches x 72 inches 1993

FORTUNE TELLER
Oil on Linen 38 inches x 54 inches 1993

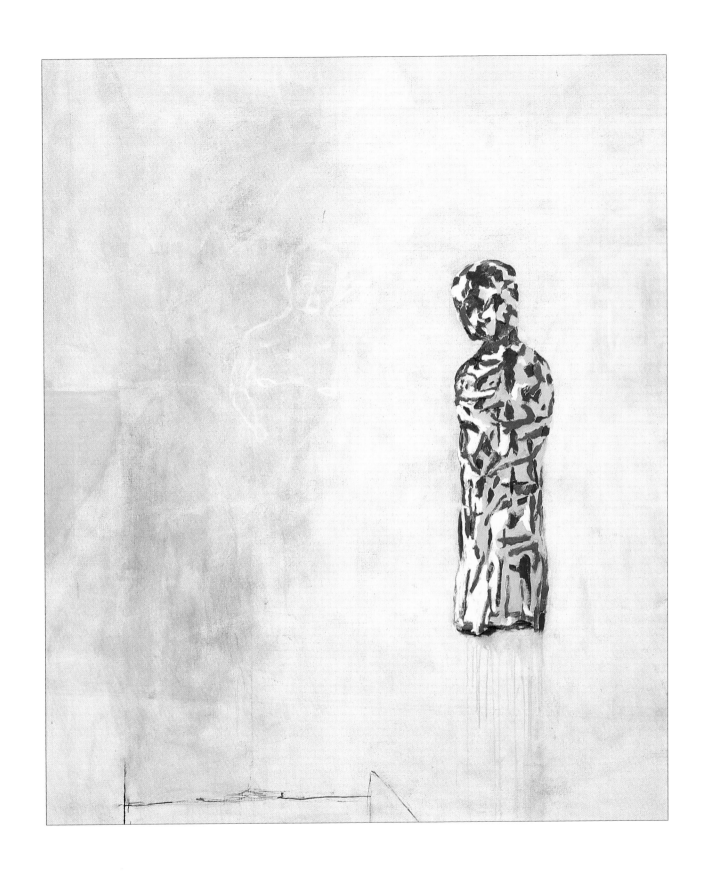

ENCOUNTER
Oil on Linen 72 inches x 60 inches 1993

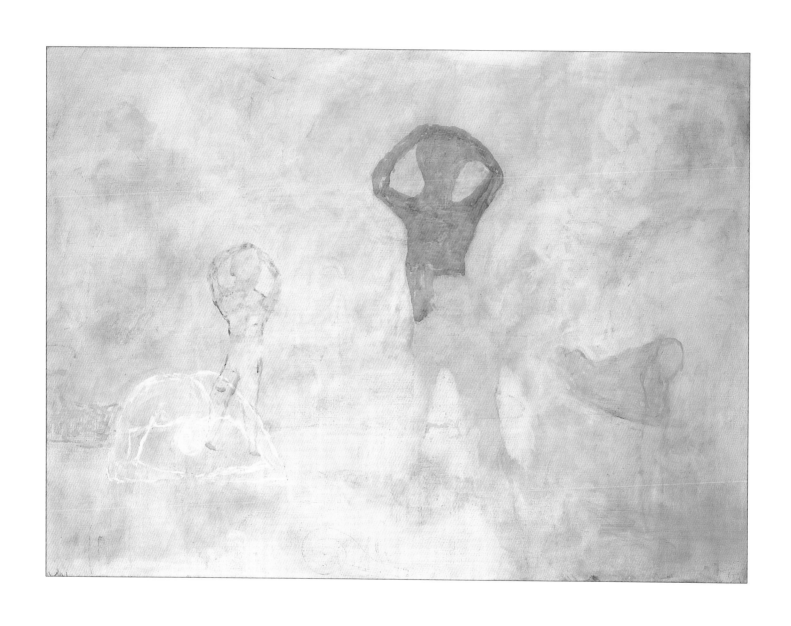

BEHIND THE BARN
Oil on Linen 46 inches x 64 inches 1994

LUMBERJACK
Oil on Linen 24 inches x 30 inches 1994

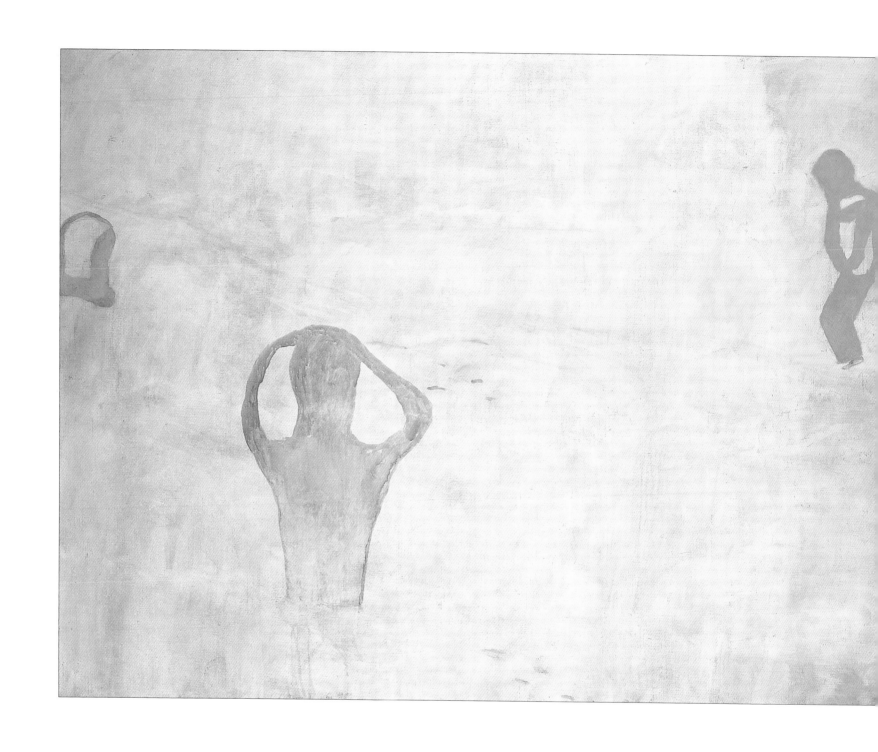

BATHERS BY A RIVER (left panel)
Oil on Linen 54 inches x 72 inches 1994

BATHERS BY A RIVER (right panel)
Oil on Linen 54 inches x 72 inches 1994

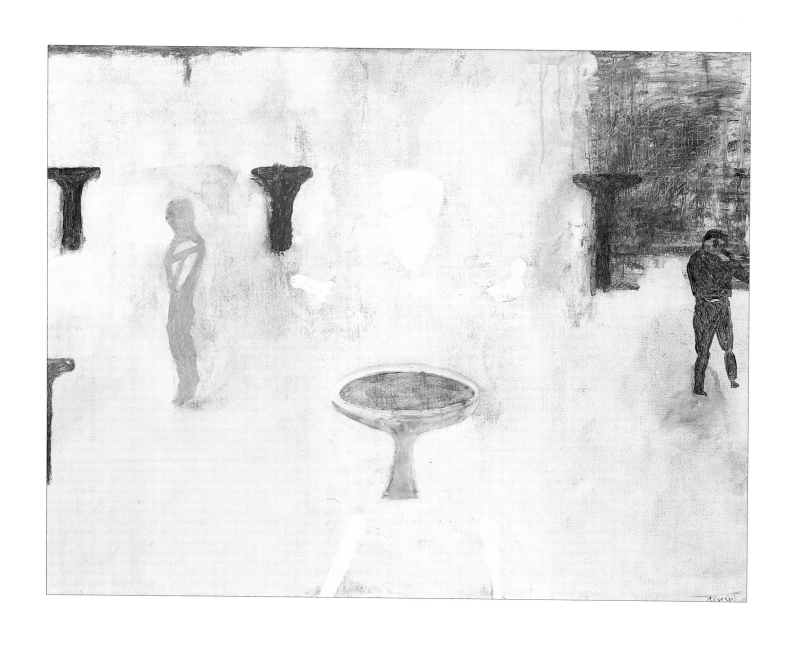

PIAZZA

Oil on Linen 23¾ inches x 32 inches 1994

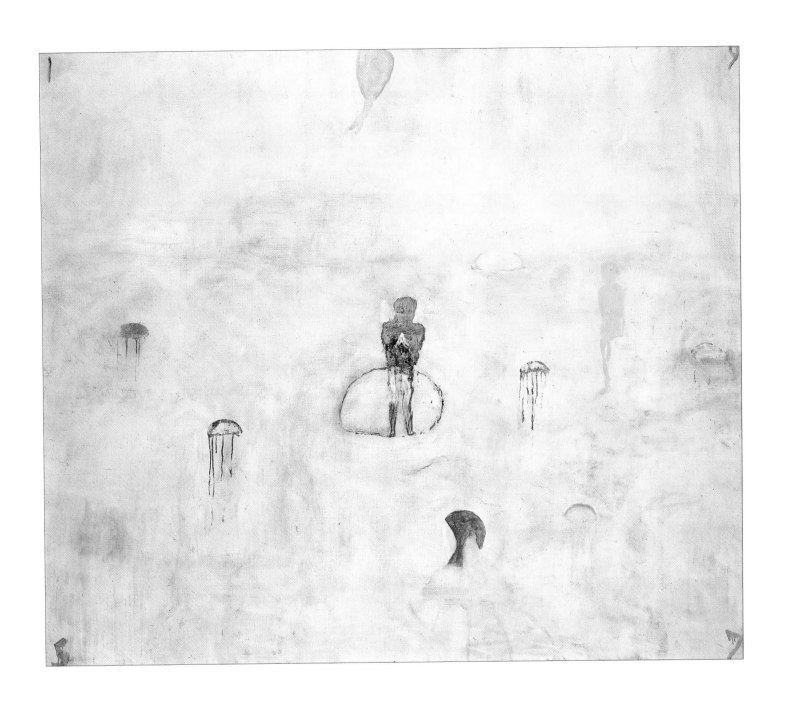

1957
Oil on Linen 50 inches x 60 inches 1994

BATHERS II
Oil on Linen 66 inches x 55 inches 1994

116

A CASE OF THE VAPOURS
Oil on Linen 16 inches x 12 inches 1994

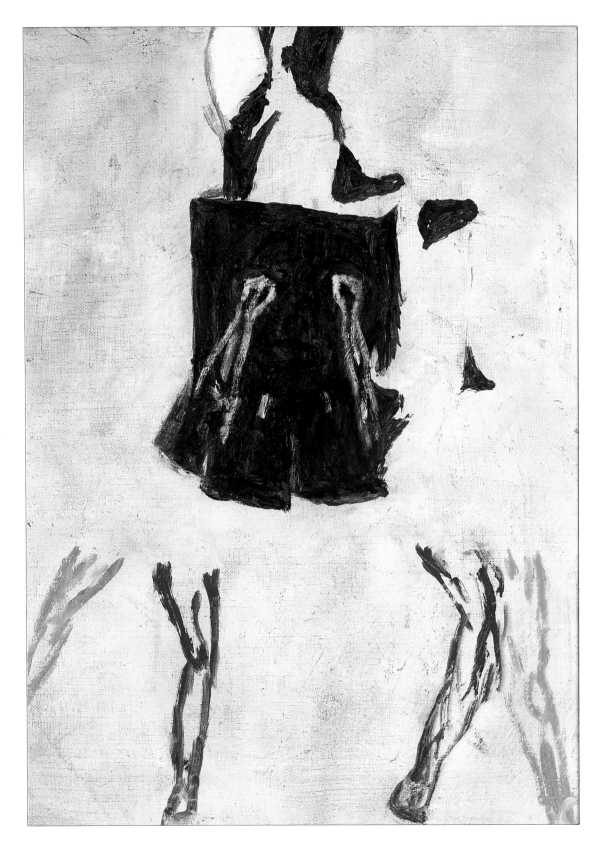

P. and Q.
Oil on Linen 16 inches x 12 inches 1994

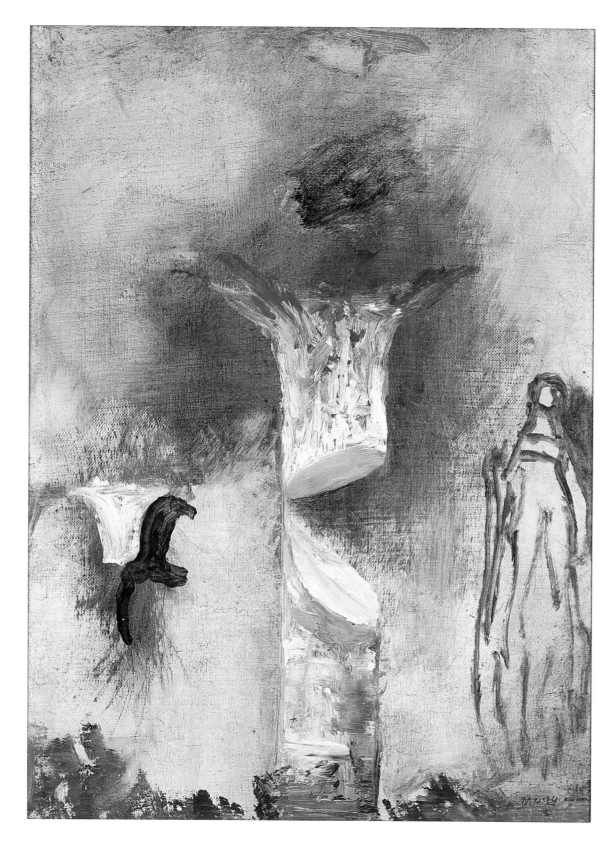

THE WOODCUTTER'S SONG
Oil on Linen 16 inches x 12 inches 1994

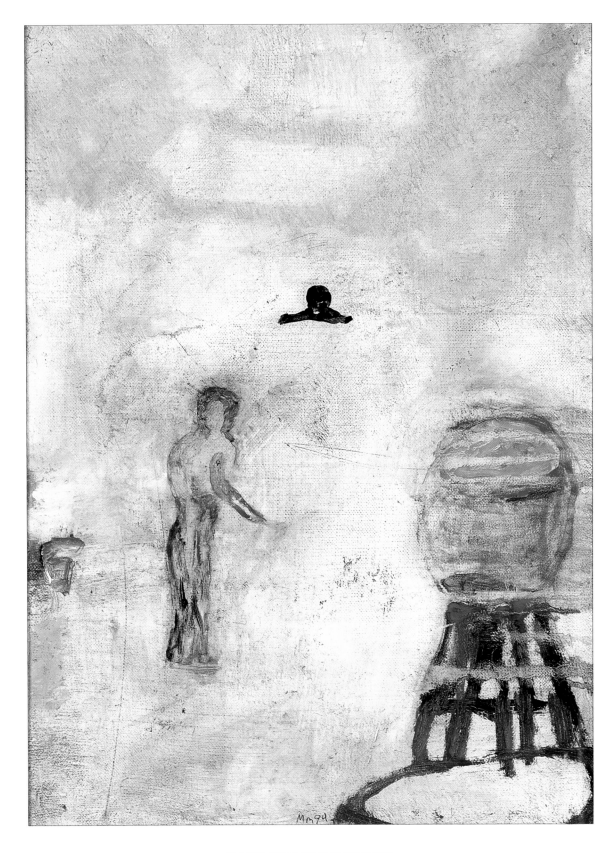

OTHER SIDE OF THE TRACKS
Oil on Linen 16 inches x 12 inches 1994

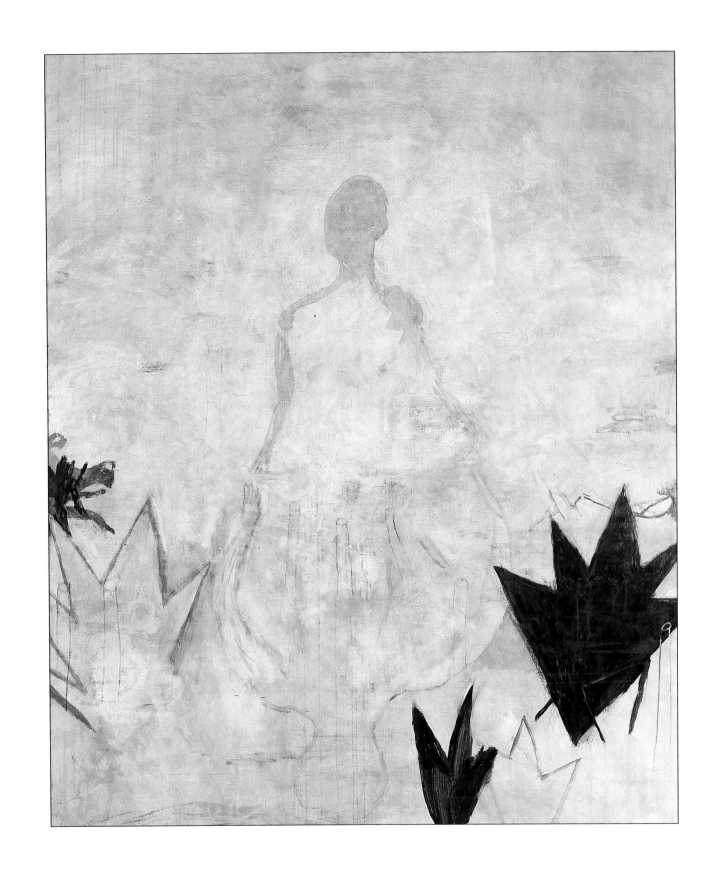

NARCISSUS
Oil on Linen 61 inches x 52 inches 1994

MARTIN MULL

EDUCATION

1967 Rhode Island School of Design, M.F.A.
1965 Rhode Island School of Design, B.F.A.

SELECTED SOLO EXHIBITIONS

1995 Cleveland Center of Contemporary Art
Cleveland, Ohio

David Beitzel Gallery
New York, New York

1994 Dorothy Goldeen Gallery
Santa Monica, California

David Beitzel Gallery
New York, New York

1993 Dorothy Goldeen Gallery
Santa Monica, California

Total Contemporary Art Museum
Seoul, Korea

1992 Sylvia White Gallery
Santa Monica, California

Barbara Singer Gallery
Boston, Massachusetts

Wake Forest University Fine Arts Gallery
Wake Forest, North Carolina

Helander Gallery
New York, New York

1991 Helander Gallery
West Palm Beach, Florida

1984 Los Angeles Institute of Contemporary Art
Los Angeles, California

1982 Molly Barnes Gallery
Los Angeles, California

1980 Molly Barnes Gallery
Los Angeles, California

SELECTED GROUP EXHIBITIONS

1993 Fourth Newport Biennial
"Southern California 1993"
Newport Harbor Museum of Art
Newport Harbor, California

Group Show
David Beitzel Gallery
New York, New York

Michael Dunev Gallery
San Francisco, California

"Ten Artists from the West Coast"
Total Museum of Contemporary Art
Seoul, Korea

"Laughing Matters"
L.A. Municipal Art Gallery/Barnsdall Park
Los Angeles, California

"Paper Trails: The Eidetic Image"
1 Space Museum, University of Illinois
Chicago, Illinois

"Humor and Art"
Mount St. Mary's College
Los Angeles, California

Group Show
Dorothy Goldeen Gallery
Los Angeles, California

1990 Group Show
Helander Gallery
West Palm Beach, Florida

1983 Group Show
Molly Barnes Gallery
Los Angeles, California

Group Show
Gallery Henoch
New York, New York

"Toys"
Greenville County Museum of Art
Greenville, South Carolina

1973 "Eat Art"
Cincinnati Institute Of Contemporary Art
Cincinnati, Ohio

"Smart Ducky"
Boston Institute of Contemporary Art
Boston, Massachusetts

"Umbrellas of Fitchburg"
Boston Institute of Contemporary Art
Boston, Massachusetts

1972 "Flush with the Walls"
Boston Museum of Fine Arts
Boston, Massachusetts

SELECTED PUBLICATIONS

Beller, Miles, "In the Slip of the Exalted"
Art Week Magazine, November 1994

Gannon, Dr. Frank, "Saturday Review Gallery"
Saturday Review
January/February 1985
pp. 45-49, illustrated

Gimelson, Deborah, "Art Review"
The New York Observer
January 24, 1994

Lee, Sung-Man, *Design Journal*
Art Center, Inc.
Seoul, Korea

Long, Marion, "Secret Passion"
Gentleman's Quarterly, volume 60
November 1990
pp. 276-77, illustrated

Morgan, Robert C., "Surface-Depth Matters"
Cover Magazine, March 1994

Muchnic, Suzanne, "Art Review"
Los Angeles Times, Calendar Section, 1984

Smith, Roberta, "Martin Mull at
David Beitzel Gallery"
The New York Times, January 28, 1994

SELECTED PUBLIC COLLECTIONS

Fine Art Museum of the University of Arizona

Newport Harbor Museum

The Columbus Museum of Fine Art
Columbus, Ohio

The Metropolitan Museum of Art
New York, New York

Total Contemporary Art Museum
Seoul, Korea